Stinking Bishops and Spotty Pigs

Gloucestershire's Food and Drink

Emma Kay

AMBERLEY

First published 2019

Amberley Publishing
The Hill, Stroud, Gloucestershire, GL5 4EP
www.amberley-books.com

Copyright © Emma Kay, 2019

The right of Emma Kay to be identified as the
Author of this work has been asserted in accordance
with the Copyrights, Designs and Patents Act 1988.

ISBN 978 1 4456 8728 5 (print)
ISBN 978 1 4456 8729 2 (ebook)

British Library Cataloguing in Publication Data.
A catalogue record for this book is available from
the British Library.

Origination by Amberley Publishing.
Printed in Great Britain.

Contents

Acknowledgements

This book was written with significant input from the local Gloucestershire community, by residents, former residents and businesses. I have been overwhelmed by the support, variety and sheer volume of stories that have come my way. It has been very difficult to include all of those stories, or to thank everyone individually who messaged me in this book, but I am grateful to you all. In particular the members and administrators of online communities such as Old Ciren, Days Gone by in Cheltenham, Gloucestershire Social History, Our History – Gloucester, Gloucestershire Connections Old and New, Gloucestershire Days Gone By, and Gloucestershire Fishing Group.

It has also been impossible to incorporate every food business or food-related enterprise into such a concise history of the county. If I have omitted any business or individuals considered to be relevant to this dialogue of food history, then I apologise. I have also consistently used social media to reach out and connect with local businesses, in an attempt to include as many as possible.

Special thanks go to Henry Herbert, Gordon Tartaglia, Jim Ball, Paul Bloxsome, Steve Lawrey, Valerie Webb, Sheila and Bob Clark, Tony Poulter, Elizabeth Beaumont, Philip Langley, Grame Bruce Fletcher, Maz Barchus, Jane Richardson, Heather Remblance, Linda Witting, Katy Blake, Sophie Tartaglia, Jenny Darch, Marie Lewis, Andrew Cuciurean, Colin Whittard and Jimmy Hipwood, Pat Whitfield, Robert Price, Marcel Boreland, Pamela Ingram, Heather Remblance, Julie Ogden, Helen Webley, Veronika Jordan, Derek Bond, Jane Regan, Margaret Stratford (née Ellis), Maureen Ellis Rickards, Sue Voaden, Carole Sharpe, Andy Aubrey, Mark Phillips, Marion Hunt, Dorothy Wallace, Pamela Wright Brogan, Judy Darch, Lorrain Keightley, David East, Matt Sykes, Richard Willis, Jane Vassallo, and Jean Young.

As always thank you very much to my long-suffering husband, Nick Kay, who tirelessly photographs for all my books and to my patient, lovely son Ben. Thanks also to my publisher who continues to support my work.

Thanks go to Charles Martell & Sons Ltd for permission to use the image on the front cover (charles@charlesmartell.com).

I dedicate this book to all its contributors and to everyone who has worked in the food sector in Gloucestershire, past, present and future. You are all marvellous.

Introduction

Gloucestershire was primarily once a county best known for its textile industries. This was born out of its shipping trade and links to the West Indies, importing large quantities of hemp and oil seed. The landscape today is littered with the remains of old textile mills and weavers' cottages, no more so than in Stroud, where some 150 mills once stood stretching across its gorge-like valley. So why the food book? you ask. Because, as William of Malmesbury reminds us, way back in the twelfth century:

> The vale of Gloucester is so called from its chief city, the soil whereof yieldeth variety of fruits and plants and all sorts of grain…enough to excite the idlest person to take pains when it repays his sweat with the increase of an hundred-fold. There you may behold the highways and public roads full of fruit-trees not set but growing naturally…There is no province in England hath so many or so good vineyards as this county, either for fertility or sweetness of the grape.[1]

It is not difficult to imagine that Gloucestershire with all its fertile terrains was once renowned for its vineyards and diverse crop production. It is a county steeped in heritage, an enigma of the British landscape. From elvers to exotic bananas, the locals of Gloucestershire have historically enjoyed not only the rewards that the land and rivers provide, they have also benefitted from imported luxuries and the industrial advantages furnished by the county's docklands and canal systems.

As Gloucestershire's ancient market towns continue to deliver high-quality food vendors, sustained by the range of local independent producers, the county is also supported by the vast spectrum of gastropubs and cookery schools that dominate the culinary scene. In particular the city of Gloucester boasts the oldest surviving complete medieval courtyard inn in Britain, The New Inn. It is also a city that prides itself in not one nursery rhyme – that of the famous Doctor Foster who went to Gloucester – but two. The second is however a little grislier and more insensitive, despite exemplifying Gloucester's food past. Oxbody Lane was an ancient narrow passageway and the main thoroughfare for cattle on their way to market. It got progressively narrower the nearer it got to the city's Northgate Street. So narrow, in fact, that one day an Ox lodged itself between the buildings either side. It couldn't be budged, so was slaughtered on the spot. The incident was marked in a nursery rhyme that starts 'There's an ox lying dead at the end of the lane.

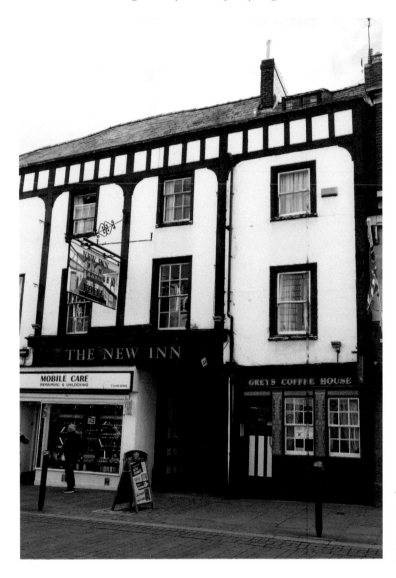

The New Inn,
Gloucester, Britain's
oldest surviving intact
medieval courtyard inn.
(© Nick Kay)

His head on the pathway, his feet in the drain.' Not one I would recommend for bedtime reading.

While 'drippers', elvers, or indeed ox may no longer present themselves as the most fashionable of local dishes, there is no doubt that the hugely popular Old Spot sausage, sourdough breads and local craft ales retain some of the many traditional elements of Gloucestershire's food past.

As with all counties, there are numerous provincial terms applied to Gloucestershire food that we no longer hear, terms like 'huff', meaning a light pastry designed to encase fruit or meat while it stews, or 'mazzards', which were black cherries. Alehouses were 'nales' and 'moseys' were potatoes. Wood pigeons were simply 'zoo-zoos' (so much more descriptive), pig's lard was more delicately phrased

The old Oxbody Lane site today. (© Nick Kay)

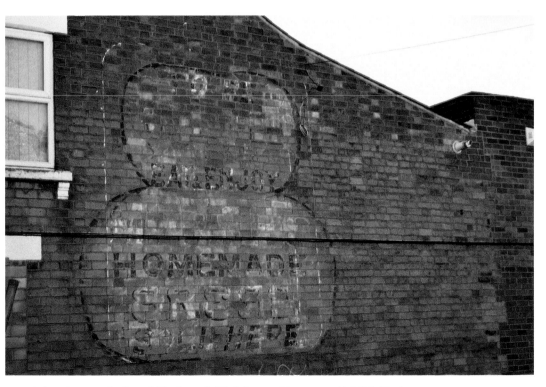

Advertisement for bread, Tredworth High Street, Gloucester. (© Nick Kay)

Baked goodies at market, Gloucestershire. (© Nick Kay)

as 'sallis', and perhaps my favourite, the 'snoul' referred to a small lump of cheese or bread, the staple diet for many once upon a time.[2] Nowadays, you are more likely to find Artisan meats, edible flowers and specialist cheeses filling the market stalls and shops of Gloucestershire.

This book will take you on a journey that explores the world of the original outdoor traders and the local resources that continue to bolster the county's food industry. Dishes, once regionally acclaimed, are both slowly disappearing, or being reinvented, like the venerable mustard ball. The local preserve and drink industry thrive in an individualistic way and butchers and bakers continue to apply traditional techniques while exploring enterprising new ventures. Gloucestershire remains a largely rural county, with a rich mix of old and new commodities. It attracts both the leading names in commercial culinary enterprise, while maintaining many of the fundamental assets that prevail at the core of its edible past.

Regional Fare and Local Dishes

Cheltenham pudding, Painswick chops, Gloucester pancakes and Blakeney fritters are just some of the dishes particular to Gloucestershire. These and other local delicacies such as county specific cheeses, Gloucestershire Old Spot pigs, Bibury trout and Tewkesbury mustard have all contributed to the narrative of Gloucestershire's food past.

Dripping cake, or 'drippers', are not exclusive to Gloucestershire, but during the 1950s it seems they were at their peak in popularity across the county and many

Nineteenth-century John Leech caricature depicting Gloucestershire as cheese and Devonshire as cider.

Former site of Leopold's
Bakery, Cheltenham.
(© Nick Kay)

people I spoke to from that time were keen to describe their experiences of them, argue where the best could be purchased and how they should be made. Shops like Leopold's and George's of Cheltenham, Sparkes Bakery, the Blue Door and Ann's Pantry in Cirencester were frequently cited as the best makers of this sticky treat.

Lardy cakes also remain a hot topic of local discussion. Similar to drippers, lardy cakes are made with pork lard, whereas drippers contain beef dripping.

The following Gloucestershire lardy cake recipe was allegedly acquired from Ann's Pantry located in the Market Square, Cirencester, which I can find records for dating back to 1923.

Ernest Sykes and Peter Kelly met while being held at a prisoner of war camp during the Second World War. They remained friends and in the 1950s Peter's wife and Ernest and his wife Joyce all became business partners in Ann's Pantry. In 1957 Ernest and Joyce bought the Kellys out and son Alan Sykes joined the business in 1964. It traded without any breaks until September 1990. Joyce passed away in 1987 and Alan's wife Jackie took on a more active role in the business until it closed, at which stage the whole Sykes family retired. The building was then leased to Michael and Paul Bird, who ran it as a bakery and café until turning it into an antiques arcade around the year 2000. Most local people today remember it being run by the Sykes family with great fondness. This story was contributed by Matt Sykes, son of Alan and Jackie, who remembers spending time in the shop when he was a child. The recipe was contributed by Cirencester resident Grame Bruce Fletcher, although the Sykes family deny they came from Ann's Pantry during the time they had ownership. Wherever the recipe originated, it makes a genuinely good bake.

GLOUCESTERSHIRE LARDY CAKE

1lb 14oz strong flour, 1/2oz salt, 1oz lard, 1 ¼ pint milk, 12oz sultanas, 4oz currants.

Mix all together and knead into a dough, then prove for one hour at 27 degrees Celsius or 80 degrees Fahrenheit.

Mix together: 12oz lard, 12oz brown sugar, 12oz ground mixed spice, then roll into the dough and give them two half-turns.

The dough is then pinned out to a large rectangle and rolled up (like a swiss roll).

Cut this into six pieces and place, cut side down, into round pans of a suitable size. NOTE the pans must be heavily greased with lard.

Allow the dough to prove, and then bake at 420 Fahrenheit or 216 Celsius.

When baked, the lardy cakes must be turned out immediately from the pans, otherwise they will stick. Take care to avoid being burned by boiling lard!

The brown sugar, on cooling, shows as a glaze.

This gives six round cakes layered with lard and sugar in whorls, and differs from Oxfordshire lardy cake and those made by Viners [a rival bakery at the time].

Both dripping and lardy cakes are traditional to Britain and are typically associated with the South West (predominantly Gloucestershire) and northern England, as well as London. There is a very sad story of a dripping cake causing the death of a sixteen-month old child back in 1908 in Cheltenham. The child was given a piece of the cake by her father which stuck in her throat, choked and killed her.[1] Perhaps this indicates the shear stodgy weight of these fatty cakes, which are coveted for their heavy, sticky consistency.

Drippers are now quite hard to come by locally. Once produced en masse in small independent bakeries everywhere across the county, it has now become a rare and scarce cake. I managed to acquire both the fruit and plain variety from Danny's Café and Bakery in Bishops Cleeve one Saturday afternoon. You wouldn't want to eat more than half a slice in one sitting. But once tasted, never forgotten. And as the nice lady we got chatting to in the nearby Kings Head pub suggested, they are even better when slightly warmed, turning the toffee-like layer into a syrupy goo.

The origins of the dripper are contentious and as already mentioned, they are not just particular to Gloucestershire. However, they are undoubtedly most cherished in this county. Rumour has it that David George, the founder of George's Ltd confection and bakery, who built up a small empire of outlets, first across Cheltenham and then further afield into the West Midlands and Cardiff, was the man behind their invention. One of David George's biggest competitors during the early 1900s was the loveable and colourful character Ernest Edward Marfell. Marfell was a director of Cadena Cafés Ltd, which became a significant nationwide chain of cafés, including the Cosy Corner situated in Cheltenham. A nice reminiscence following his death was published in the *Gloucestershire Echo* on Thursday 29 June 1944, remembering a time when four regular customers of the Cosy Corner requested a free champagne dinner in recognition for their three years of loyalty to the café. Marfell agreed, on the basis that they return later, once he had transformed his café into a restaurant. He then set

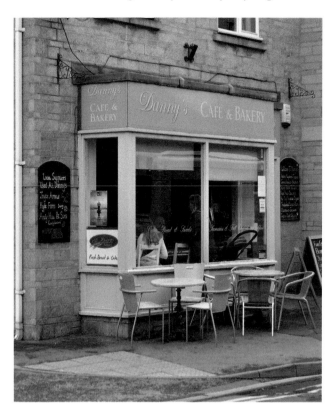

Left: Danny's Café, Bishop's Cleeve. (© Nick Kay)

Below: 'Drippers' from Danny's Café, Bishop's Cleeve. (© Nick Kay)

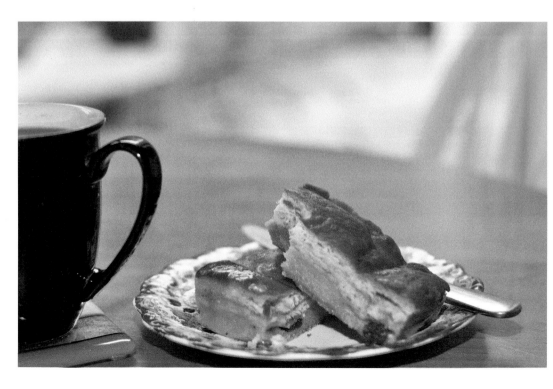

King's Head public house, Bishop's Cleeve. (© Nick Kay)

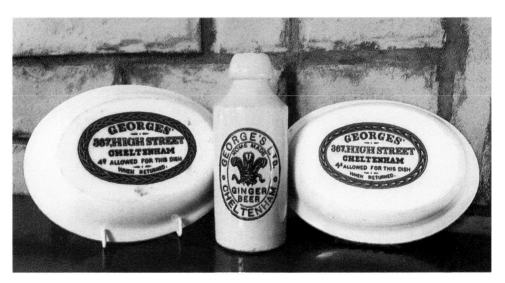

Artefacts from George's Ltd of Cheltenham, from the collection of Steve Lawrey. (© Steve Lawrey)

the table in front of the windows facing out onto the street. The outcome was that the whole of Cheltenham Promenade became gridlocked, with the police arriving at the Cosy Corner to shut it down. It turns out the scene created in the café's window was so vibrant and visual that everyone in their cars slowed down to watch the dining

Cheltenham Promenade today, where the old Cadena Café once stood. (© Nick Kay)

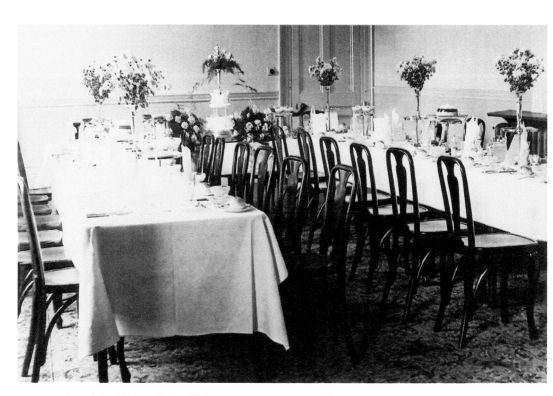

Interior of the Cadena Café, Cheltenham, 1939. (© Paul Bloxsome)

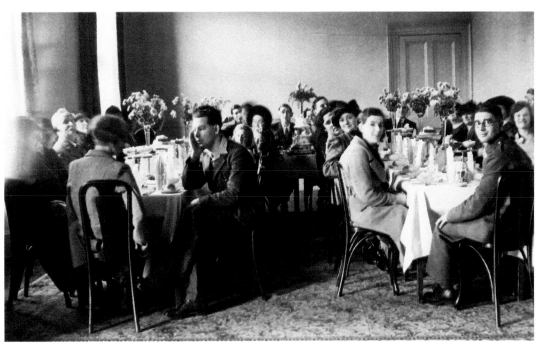

Paul Bloxsome's grandparents on their wedding day at the Cadena Café, Cheltenham, 1930s. (© Paul Bloxsome)

The Waterways Museum, Gloucester. (© Nick Kay)

spectacle, blocking the entire road. The article noted that this was just one of many examples of Marfell's outlandish PR opportunities for his business. At some point the Cosy Corner became the Cadena and reopened, still as the Cadena, in the High Street later in the century. The interior was described by local Andrew Cuciurean as having 'Sweeping stairs, palm trees, beautiful cakes and staff who were trained in the art of service, a fantastic afternoon out.'

Former Gloucestershire resident Paul Bloxsome's grandparents had their wedding reception at the Cadena in the 1930s, complete with resplendent dining tables and the prettiest of wedding cakes. But, it is Dorothy, Paul's grandmother, who holds a much more important historical link to both the county and the wider country, more of which you can discover by reading about the Bath Tavern in chapter 'Producers and Cooks'.

With Gloucester's ship canal opening during the second decade of the 1800s, imports of wine and spirits from France and Portugal would have meant greater access to alcoholic drinks. Local traders were frequently penalised for selling these types of beverages without a proper licence. In 1830, this would have cost them at least £20 old pounds – around £1,500 in today's currency, a whopping fine.

In his book of 1796 on rural economies, William Marshall outlined the three principal drinks being made in the county at this time: cider, perry and a mixed cider made from both apples and pears.[2] Plentiful new cider apples were planted throughout the county

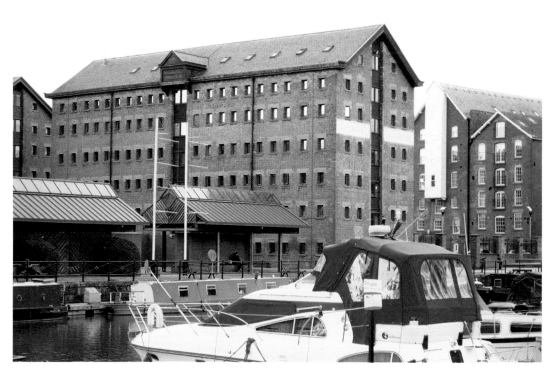

Gloucester Docks. (© Nick Kay)

during the eighteenth century, when the expansion of the canal networks increased the market for this most palatable of drinks. There are numerous historic cases of stories in the media relating to death by consumption of cider across Gloucestershire, from lead contamination (cider stored in containers with lead), drunken accidents and violent incidents, murders and in some cases drowning in local canals as a consequence of being intoxicated with cider. Beer and cider also became more popular throughout the nineteenth century generally, when retail sales of both these drinks were made permissible in an attempt to curb the evils of gin and other knavishly produced spirits nationwide. Today, local businesses like the Cotswold Cider Company continue to innovate this most ancient of beverages with quirky craft bottles of Sweet Cheeks, No Brainer and Blow Horn varieties, to name a few.

With all its beautiful rivers and waterways, Gloucestershire unsurprisingly has a close relationship with freshwater fish and eels. I knew all about elvers and their unusual culinary pairing with scrambled egg long before starting to write this book. I understand that the word 'fare' was a derivative of 'way-faring', the term describing the movement of the eels upstream. From eel-fare, you then got the word elver. What I didn't know were some of the great stories attached to this once highly revered and consumed county commodity. It was once common to see street sellers hawking pint-sized measures of eels, together with the river slime and water they were caught in, to anyone who came along with their own container.

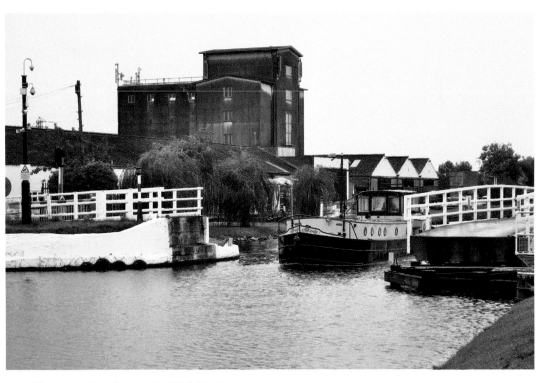

Gloucester Canal scene. (© Nick Kay)

Throughout the early 1800s there are countless references in the press to people being fined for fishing and selling elvers out of season. There is even one very sad account of a little nine-year-old boy falling to his death into the River Severn while hunting this once most locally of revered young eels.[3] Elvering was a dangerous business, nearly always carried out at night as the eels are attracted to lights, which the fishermen laid out along the banks of the river. The tides were unpredictable, leaving you ankle deep one minute, waist high the next. Very large scoop-shaped nets were used to trap the elver shoals.

Colin Whittard and Jimmy Hipwood both remember the selling and fishing of elvers locally, the former in the 1950s, when 'As a young lad, I used to be sent out in the early hours to scour the neighbourhood of Seymour Road/Bristol Road looking for the telltale sign of a towel draped over a chair indicating that elvers were for sale. The going rate then was around six pence (yes, a tanner) for a pint mug. If all else failed Tom Ravenhill usually had a tin bath full at his shop on the corner of Alma Place.' Tommy Ravenhill's shop was a general store. Colin remembers taking the old fizzy pop bottles back in return for a threepenny and then jumping over the wall to steal them back when no one was looking.

Jimmy recalls fishing with his friends throughout the 1960s, '70s and '80s, along the whole stretch of the River Severn from Newnham to Tewkesbury. They then sold their catch on to other friends and neighbours from out of each other's houses. If they

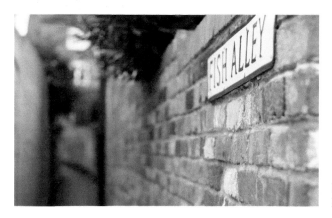

Fish Alley, Tewkesbury. (© Nick Kay)

Near Hempsted Bridge, Gloucester, and its old elver station. (© Nick Kay)

caught a big haul, they took it to the elver station in Bristol Road, Gloucester, located just past Hempsted Bridge. Jimmy was reminded of being at the elver station one night when a local lad with a good catch from the Tar Works at Sandhurst village came into the station and asked about prices for trayed and loose elvers. He had around sixteen dustbins and claimed that the elvers were still running when he left; he simply hadn't enough containers to store them in. If he had used trays, Jimmy confirmed, the haul would have amounted to thousands of pounds. When you took your elvers to a station, you put the eels in trays and then they were weighed for you. You were then issued with a ticket for the amount you brought in and given cash in exchange.

There was another elver station located at the village of Epney near Gloucester. This was sold off in the 1950s. Prior to the First World War, the German Fisheries Association were interested in importing elvers regularly from the River Severn, in order to restock German rivers. After the war, work with developing the elver station – fitting extra storage tanks and pumps etc. – continued and there were many rumours at the time that the site had become a secret German military base.[4] The Anchor Inn, Epney, was on the same site as the well-known elver-weighing station. A Polish doctor established part of the grounds of the inn, rented from the landlady, and added the necessary tanks and filter systems. The business was originally managed by Polish workers. The Ministry of Agriculture and Fisheries took control of the station around 1948, with a view to expanding the business and exporting elvers widely to Holland, Poland and other countries throughout Europe. The scheme failed and the station was sold off as a private sale. By 1950 it was in the hands of a Mr Rogers, the landlord of the Anchor Inn and the caretaker for the elver station, who made a statement that year bemoaning the fact that elvers were in abundance and local traders were struggling to sell them in the markets and on the streets.[5] As the inn is situated on the River Severn, many local fishermen would go and catch their hauls, taking it straight over to the inn to be weighed. In some cases people were using them to feed their livestock, as Jimmy Hipwood recalls on witnessing a man from Priory Road, Gloucester, filling a large old bathtub with elvers for his chickens to guzzle down. One-time local elver fisherman Robert Price remembers Epney station in the early 1980s. He described it as being located a couple of hundred yards from the

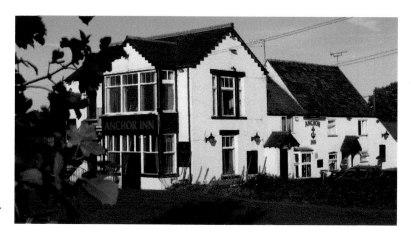

The Anchor
Inn, Gloucester.
(© Nick Kay)

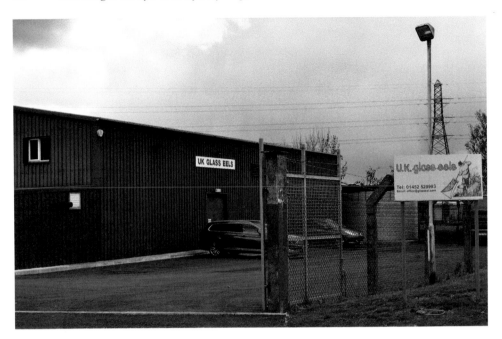

Glass Eels, Gloucester. (© Nick Kay)

Anchor Inn, at the other end of the flood wall. It was in an old house, run by 'a wiry thin and sometimes aggressive elderly man who served you through a window'. The man paid less than the Bristol Road station, but he would take 'dead weight' (elvers in buckets as opposed to trays) and there would often be arguments as the price could swing dramatically throughout the night. Robert described how the old man had two rather savage Doberman guard dogs and he growled almost as much as they did.

The Bristol Road station was a more professional enterprise and today the old site is occupied by the sustainable Glass Eel Company.

Despite the dangers of elvering, it could also be lucrative and it was possible to catch a week's or even a month's wages worth of eels in just a couple of minutes. Robert called attention to the fact that even after you had risked your life in the water late at night, there was still the issue of trying to smuggle your eels across open countryside, in the dead of night, while defending yourself from attackers and robbers wanting to steal your catch. Then you had to avoid angry landowners, or thieves pretending to be angry landowners and risk prosecution for trespassing. The waterways employed bailiffs who could approach you for your licence at any opportunity, a licence that was often too expensive to acquire at the beginning of the elver season. These were accompanied by police boats who used stealth tactics to creep up on small boats using illegal trawling nets, then chase them up the river after revving up their outboard motors. Don't try this at home kids!

Elvering altered tremendously between the 1960s, when you couldn't give them away, to the high price they afforded in the 1980s, a time when 1 kilogram of elvers could match a person's average daily wage. More elver fishermen were taking the risks,

but stocks of eels were reduced considerably, due in part to large French trawlers out at sea yielding big loads and then selling them on to the Japanese market. The process of elver fishing has been one which has surprised me the most during the research of this book. I would never have guessed that it was such a covert operation, such a dangerous and often sordid job that required nerves of steel and strength of character. Stories worthy of a Tom Cruise film script surely.

Pat Whitfield who lives in Sandhurst, Gloucester, recalled how during the 1960s and '70s she and her husband would cobble together a net from withy (like willow), the branches of which they heated in the fire to bend into the traditional scoop shape. They then attached net curtains as a makeshift catcher. Their neighbour had an elver station on his land, where, during elver season, big lorries from Austria would regularly pull up and fill up with eels to take back and restock lakes on the Continent.

At Frampton-on-Severn County Fair, each year one of the main attractions was the elver-eating contest. As stocks of elvers became steadily depleted after the 1980s, the competition was cancelled, before being recently revived again in 2018. Traditionally the eels were fried on-site over an open fire, with locals competing to consume around a pound of them – or up to 1,000 eels in one sitting.

A fish called twait, shad or May fish would also swim up the Wye and Severn in numbers in the month of May (hence the name). They were prized for their roe but the boney carcass was discarded. Local fisherman Marcel Boreland recalled that so many of these types of fish were caught that it would make the banks of the Wye shine like silver in the sunlight from all their scales. Gudgeon was another popular fish, caught and fried like whitebait. Marcel also recounts an old story of a 9-foot sturgeon caught in Berkeley

Outbuildings near Sandhurst, Gloucestershire, close to the old elver station. (© Nick Kay)

Historic Bibury. (© Nick Kay)

during the earlier part of the last century. Many locals recall fishing for what they could as children and selling door-to-door to local restaurants or to the fish markets in Gloucester.

There were once, I have been told, notorious rival salmon fishing gangs in Blakeney and Lydney during the 1950s. The material from this alone might make a fascinating little book one day.

Trout is also a much-coveted fish of the Cotswolds. For centuries people have fished in the River Coln, Bibury. Historically the Swan Hotel owned the trout fishery in the village. Today it is run by Bibury Trout Farm, complete with on-site café, BBQ and 'catch your own' attractions. In 1900 the leaseholders of the Swan Hotel Fisheries, Mr and Mrs Woodman ordered a considerable consignment of the two-year-old 'fario' variety of brown river trout from Hampshire to improve trout supplies to their fishery.[6] Several years later Arthur Severn, a relative of the famous artist and critic John Ruskin, established a hatchery in Bibury and since then it has remained a hatching and spawning haven for both brown and rainbow trout.

Pork is one of the meats best associated with the county. The Painswick chop, said to have emerged from the town of the same name – also known for its Rococo Garden, sleepy nature and idyllic landscapes – is a bacon chop baked in the oven in cider, brown sugar and mustard.

Despite spotted pigs being around for at least the last few hundred years, the official breed society for Gloucester Old Spots was not established until 1913. It is thought that the old native English pig was bred with imported Neapolitan pigs in order to create

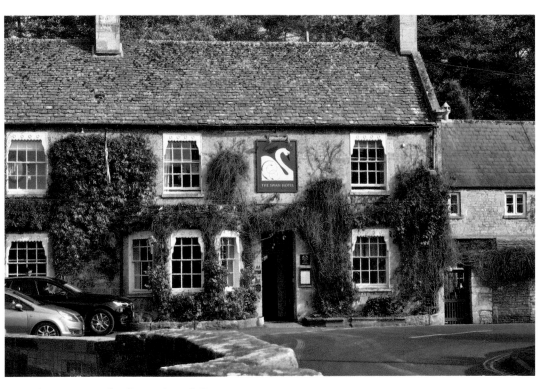

The Swan Hotel, Bibury. (© Nick Kay)

Bibury Trout Farm. (© Nick Kay)

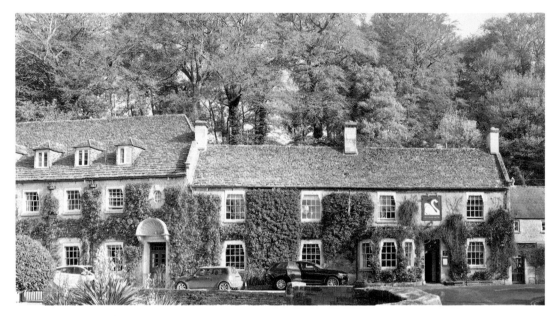

Bibury. (© Nick Kay)

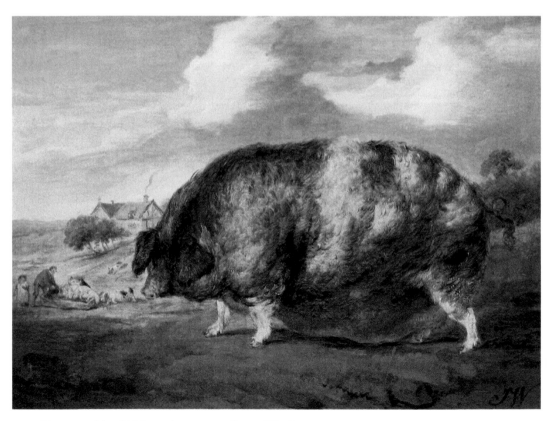

Gloucestershire Old Spot pig, *c.* 1800. (James Ward)

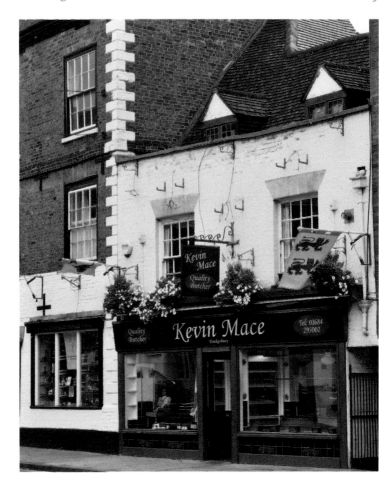

Kevin Mace
butcher's shop,
Tewkesbury.
(© Nick Kay)

the spotted outcome, somewhere in the 1700s. Sometimes called the cottage or orchard pig, as they are at their happiest in orchards feeding off windfallen apples, the Old Spot variety has traditionally supplied both pork and bacon. In 1977 the Old Spot was officially an at-risk breed, with only thirteen boars and fifty-seven sows known to exist. If it hadn't been for leading breeder George Styles and his family, who conserved 80 per cent of the total global population of Gloucester Old Spot pigs, we may no longer be enjoying this most hardy and robust of local animals.[7] Ironically, in 1975 there was a revival for the old Gloucester sausage being put back on the menu, but the shortage of Gloucester Old Spot pigs meant that the sausage makers of the time attempted to recreate the unique flavour of the Old Spot meat by adding an undisclosed mix of various herbs and spices.[8] Perhaps this was one of the contributory factors to saving the breed several years later. Today the Gloucester Sausage Company, along with just about every good local butcher in the county, make and sell the traditional Old Spot sausage.

Tony Poulter was a child in the 1940s and '50s. Growing up in Cheltenham his family regularly dined on the meat that his father brought back from his job as a sports club steward. He remembers all the leftover minced-up meat used for a variety of

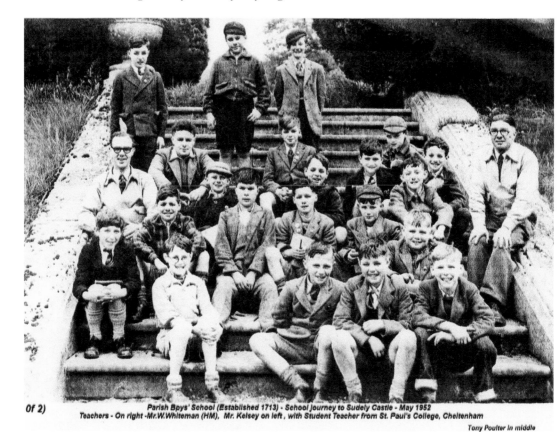

Parish Bpys' School (Established 1713) - School journey to Sudely Castle - May 1952
Teachers - On right -Mr.W.Whiteman (HM), Mr. Kelsey on left, with Student Teacher from St. Paul's College, Cheltenham

Tony Poulter in middle

Picture of Tony Poulter (in the middle, third from top/third from bottom up), 1952.

dishes, which always had an OXO cube added for extra flavour. The fat from roasted joints provided a tasty after-school snack, spread onto bread and sprinkled with sugar. Takeaways for Tony's family involved a half-mile walk to the 'faggots and peas' shop in Lower High Street. Tony's mum would give him a glazed bowl with a piece of string and a muslin cloth, to carry six faggots in gravy, with a couple of ladles of hot peas for around six old pence. Tony describes this same street as having two 'proper' butcher's shops, a 'superb' fish shop, a bakery, two fish and chip shops, two greengrocers, an ice-cream factory (where he frequently pilfered broken ice-cream cones) and an array of general grocery shops. Tony also recalls 'Andy's Candys', a small sweet factory located in Tewkesbury Road from the 1930s until the 1950s and in Clarence Street, Cheltenham, in the 1920s and possibly earlier. From here, a small conical bag of finest pear drops and sherbets could be purchased for a farthing. A farthing could also buy you a bag of 'scratchings' (the small bits of fish batter and chippings from the fryer).

Andy's Candys seems to have been trading in confection in one form or another since the 1850s and boasted about its heritage frequently in the local press. From what I have found, the business appears to have been sold in the late 1950s, when manufacturing transferred to London.

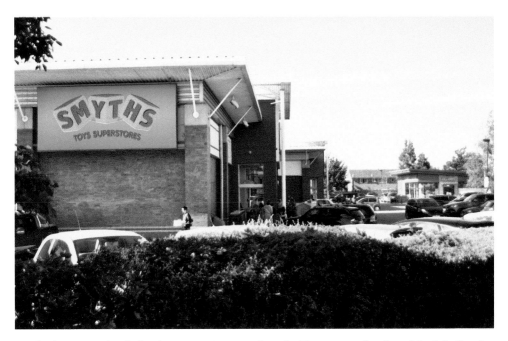

Tewkesbury Road, Cheltenham, running past Smyths Toys, once the site of Andy's Candys original premises. (© Nick Kay)

Staying on the theme of sweet treats, Blakeney fritters were small balls of dough served with a jam sauce – I imagine a bit like a baked doughnut – while the more exotic 'Badminton eggs' called for the inclusion of pickled mushrooms and truffles. This is not as unlikely as it sounds as some of the forests of Gloucestershire are well known for their truffle supplies, although their exact locations have to remain a secret to avert gangs of commercial foragers. If it's local truffles and truffle-related products that you're after, South Cerney-based TruffleHunter are probably the best you can source locally today.

Perhaps one of my least favourite local recipes is for Gloucester jelly, a dish designed for the infirm, containing, among other delights, powdered rice, sago, pearl barley, sea holly and hartshorn shavings (the distillation of deer horn), a concoction, one imagines, that would have you running towards the toilet as opposed to its desired medicinal intention. Another has to be for badger ham, a process similar to curing pork, by salting, hanging and smoking the meat of a badger. Badger hams were very popular believe it or not during the Victorian era. The British author and conservationist John Moore, who was local to Tewkesbury, wrote a number of observational stories regarding local village life and in his 1959 book *Man and Bird and Beast*, he recalled a badger ham feast that took place at Lower Lode Inn, Forthampton. The owner at the time, Bob Sivell, was a known badger hunter. His obsession was so extreme that he once held up traffic between Elbury and Birmingham to dig a trench and kill a badger caught in a road drain.[9] What a thoroughly charmless man Mr Sivell must have been and not at all in keeping with his name.

Tunley Farm, formerly known as being part of the old Daneway manor estate, was a remote farmhouse near Stroud owned and occupied by John Hancox and his son Henry along with their family in the early part of the nineteenth century. In November 1832 Tunley Farm became the site of a brutal and violent crime when two burglars, James and Thomas Berryman, hid in the property's surrounding trees, but were spotted by Henry, who dashed into the house to retrieve his gun and warn the rest of the family. As he was loading the gun he was shot in the head and blinded instantly, falling to the ground. His father John then watched as the burglars set fire to some paper to light a candle, bolted the house doors and then continued to threaten Henry and his wife with a sword and two pistols, requesting money and goods. John Hancox handed over all the cash he had on him, together with the keys to the silver cupboard. They continued to ransack the house, one plundering, while the other stood guard over the family with a gun.

Despite being disguised with painted faces, the two intruders were recognised and brought to trial, whereupon James (who fired the gun that permanently blinded Henry) was sentenced to death and Thomas was transported to the New World.[10]

Henry Hancox died suddenly at Tunley Farm in his sixties and is recorded as being a 'highly-respected gentleman farmer [who], possessed one of the finest picturesque, though small estates in Gloucestershire'.[11]

So, why am I recounting all of this? Simply because I came across an interestingly named Gloucestershire recipe for 'Old William Bucknell's Tunley Farm Ham'. Following Henry's death the farm was sold to a Mr Dangerfield and I can find no reference to a William Bucknell living there. However, the Bucknell name is renowned in the local surrounding

OLD WILLIAM BUCKNELL'S, TUNLEY FARM.
(Recipe for Home-cured Ham)

1 lb. common salt
2 ozs. saltpetre
1 lb. bay salt

1 oz. black peppercorns
(crushed)

With these ingredients well mixed and pounded, rub the ham for one hour; let it remain covered with this pickle for four days, then add 1½ lbs. treacle or sugar, rub and turn it every day for a month. Then take it out of the pickle, wash well with cold water, dry and hang in a cheese-cloth bag in a cool place. The ham should not be smoked, and do not squeeze when soaking before boiling. It will hang six months or more. If the ham is larger than 18 lbs., it should remain in pickle a few days longer; if smaller, not quite so long.

CIRENCESTER W.I.

'Tunley Farm Ham' recipe, taken from *Gleanings from Gloucestershire Housewives*. (© Emma Kay)

Speech House, Coleford. (© Speech House Coleford)

area of Tunley Farm, headed up by a shepherd, William Bucknell, who died in 1891. From this we might assume that William may have worked for the farm or at least would have had some sort of connection with the Hancox family during his lifetime. Sadly, Tunley farmhouse was demolished in 1972, but some of the farm buildings remained.[12]

Speech House pudding was a delicacy once served during each annual festival of the Forest Law Courts. Speech House in the Forest of Dean was one of six lodges contained within the Forest Law Courts of the Middle Ages. Charles II occupied the lodge during his reign, for the purposes of hunting. Essentially, Speech House pudding is a steamed sponge served with jam. Today the property stands as a stylish hotel, its function since at least the mid-1800s. It lovingly continues to pay homage to the pudding with an original recipe that hangs on the wall of the hotel's foyer.

Speech House isn't the only sweet, sticky pudding associated with Gloucestershire, which since the mid-1980s has been home to the affectionately received Pudding Club. Located at the Three Ways House Hotel, Mickleton, Chipping Campden, each week visitors to the club observe a 'parade of seven puddings', culminating in a group vote to decide the best one.[13] The club was originally established by Keith and Jean Turner, former owners of the hotel. During the era of nouvelle cuisine, the club represented a gastronomic retaliation against the fashion for small portions and the disappearance of traditional fayre.

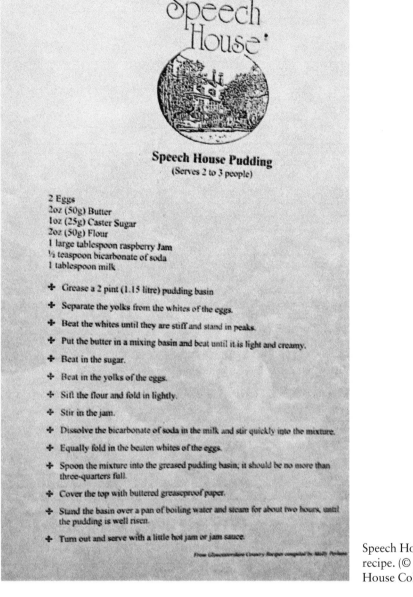

Speech House Pudding
(Serves 2 to 3 people)

2 Eggs
2oz (50g) Butter
1oz (25g) Caster Sugar
2oz (50g) Flour
1 large tablespoon raspberry Jam
½ teaspoon bicarbonate of soda
1 tablespoon milk

✤ Grease a 2 pint (1.15 litre) pudding basin

✤ Separate the yolks from the whites of the eggs.

✤ Beat the whites until they are stiff and stand in peaks.

✤ Put the butter in a mixing basin and beat until it is light and creamy.

✤ Beat in the sugar.

✤ Beat in the yolks of the eggs.

✤ Sift the flour and fold in lightly.

✤ Stir in the jam.

✤ Dissolve the bicarbonate of soda in the milk and stir quickly into the mixture.

✤ Equally fold in the beaten whites of the eggs.

✤ Spoon the mixture into the greased pudding basin; it should be no more than three-quarters full.

✤ Cover the top with buttered greaseproof paper.

✤ Stand the basin over a pan of boiling water and steam for about two hours, until the pudding is well risen.

✤ Turn out and serve with a little hot jam or jam sauce.

From Gloucestershire Country Recipes compiled by Molly Perham

Speech House Pudding recipe. (© Speech House Coleford)

Then, of course, there's Cheltenham pudding, which is a baked rather than boiled or steamed pudding. It is a recipe that made its first appearance around the mid-1800s, while its predecessor, Cheltenham cakes, which are more of a sweet bun made with yeast, were popular at least a century prior to this.

Gloucester also has its own pudding, a steamed suet and dried fruit variety, along with its very own pancakes, also made of suet. I'm not sure how the recipe for this works out, but the following appeared in *Gleanings from Gloucestershire Housewives*, 1948:

Gloucester pancake
3oz suet
6oz flour
1 egg
1 dessertspoonful of milk
1 teaspoonful of baking powder
1 pinch salt

Chop suet finely, add flour and salt; stir well. Beat the egg and add the milk to it. Mix with dry ingredients to a stiff paste and lastly add the baking powder. Place the mixture on a floured board, roll out about half-an-inch thick, cut into little rounds, and fry in hot lard until thoroughly cooked and a nice brown colour. Serve with either syrup or a good sauce sweetened with syrup.

There is a rather amusing tale recorded in *Norman's History of Cheltenham* of an incident in 1851 involving the pelting of a pancake seller on Shrove Tuesday outside Cheltenham College. His pancakes were so bad that customers ransacked the stall and for some time continued to throw his product and ingredients back at him. The case came before magistrates, but was later settled out of court. Perhaps the vendor had been selling the Gloucester variety at the time?

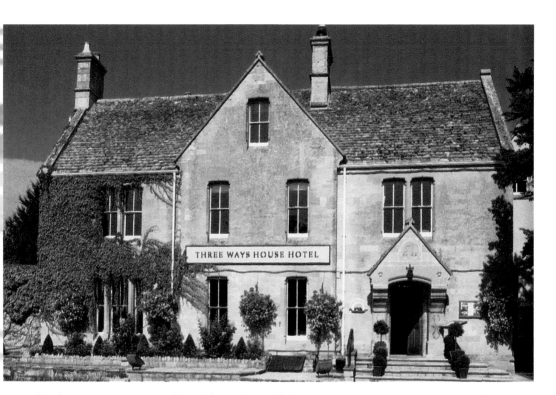

The Three Ways House Hotel, Mickleton, home of the Pudding Club. (© Three Ways Hotel)

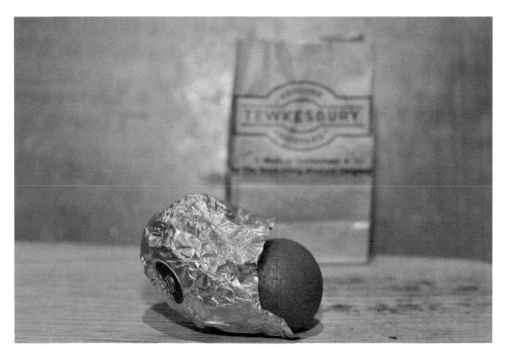

Tewkesbury Mustard Company mustard ball. (© Nick Kay)

One of the oldest and most distinguished products to emerge from Gloucestershire must be Tewkesbury mustard, dating back as early as the 1500s and perhaps beyond. It even gets a mention by the Bard in *Henry IV, Part 2*, when Falstaff describes Ned Poins as having 'wit's as thick as Tewkesbury Mustard'.[14] Introduced to England by the Romans, mustard seeds are recorded as having been ground down and used in domestic kitchens as early as the fourteenth century. The town of Tewkesbury became known for its mustard balls, combining ground mustard seeds, horseradish and other herbs and spices, then mixed into balls and dried. These balls were then sold and distributed in abundance across the country. Once bought the balls could be rehydrated with any liquid such as honey or vinegar and used in cooking or to assist with a variety of ailments. Although production of the original mustard balls ceased many years ago, it has in more recent times been revived by the Tewkesbury Mustard Company, who claim to be the only producers of Tewkesbury mustard and actually make it in the town itself. Originally, the Mustard House in Barton Street, Tewkesbury, stored the mustard grain on the floors of its upper storeys to dry prior to the rolling process.

Fermitty or frumenty was a fairly widespread dish, believed to have its origins in the Forest of Dean during the Middle Ages, although it is referenced back as early as Roman Britain and was often eaten at breakfast or as a late supper, hot or cold – a treat for the labouring classes during the 1700s and 1800s and later more associated with Mothering Sunday. Essentially, fermitty is a sweet dish made by boiling wheat grains in milk and flavouring this with raisins, sugar/honey and nutmeg or cinnamon for around an hour and then beating in eggs to thicken it. It has at times been associated with Christmas and associated with the origins of the first Christmas pudding.

Mustard House, Barton Street,
Tewkesbury. (© Nick Kay)

Of course, It isn't possible to write a book about the history of food in Gloucestershire without referencing cheese. The traditional semi-hard cheese made from Gloucester cattle, of the single and double variety, is as much recognised for its heritage and brand as it is for its well-known rolling capabilities. It is said to have originated in the small town of Berkeley, also famous for giving the world Dr Edward Jenner, the scientist who pioneered the smallpox vaccination with the help of Gloucester cows. In fact, it was once even locally called Double Berkeley at some stage during the nineteenth century. Now better known as Double Gloucester, this cheese has a legendary status, together with its slightly less thick companion Single Gloucester.

Back in the early 1800s Single Berkeley, or Gloucester, was manufactured nationally. The Double variety was, however, only produced in Gloucestershire and limited to the summer months of May, June and July. Single Gloucester was traditionally made from April to November.[15] The cheese has allegedly been made in the county since the sixteenth century and the earliest mention of it I could find in the media was 1758, when it was interestingly listed as Single and Double Gloucester, not Berkeley.

Double Gloucester was being sold at Stourbridge Fair in the 1700s at a cost of fifty-two–fifty-six shillings. That would be equal to well over £200 in today's money.[16] Today, you are more likely to find Single and Double Gloucester on sale at somewhere like local cheesemaking experts Godsell's Cheese, for a lot less lucre.

Cheese rolling, if you didn't already know, is synonymous with Gloucestershire, specifically on Whit Monday, now the spring bank holiday at the end of May.

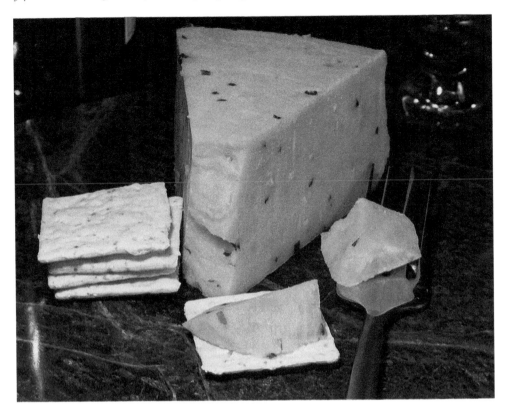

Above: Cotswold Double Gloucester cheese.

Left: Godsells cheese at local farmer's market.
(© Nick Kay)

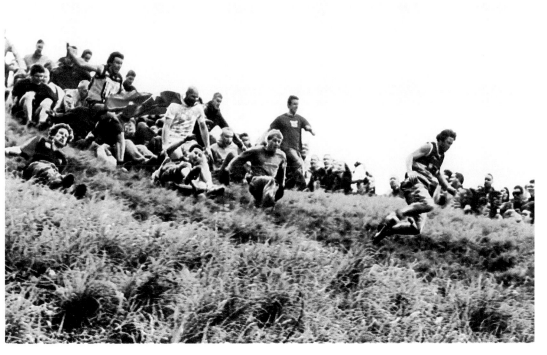

Cheese rolling at Cooper's Hill. (Courtesy of Michael Warren under Creative Commons 2.0)

The annual event involves hundreds of spectators watching around thirty or forty people (traditionally only men, but now women participate) running after a cheese down Cooper's Hill, Brockworth. The speed and gradient of the hill results in broken limbs and worse, but it remains rooted in local custom. Cooper's Hill was originally a sprawling romantic villa with coach house, stables and two walled gardens and 7 acres of land, built sometime in the 1600s and occupied for many years by the Thayer family and described as a 'lone house' in a number of publications.

The cheese-rolling event was at some time during the 1800s christened 'Cooper's Hill Wake' and incorporated a day of activities including donkey racing, hunting a pig with a greasy tail and sack racing, with the earliest record I can find dating to 1837. Thomas Baskerville wrote about the 'scouring' of nearby Uffington White Horse in 1677. This was the practice of cleaning the numerous large chalk figures that were cut into the landscape centuries ago. An ancient song, which is undated but relates to the scouring festivities, includes an interesting verse that could verify the early origins of the cheese-rolling jollity:

> They'll be backsword play, and climbing the pole,
> And a race for pig and cheese;
> And we think as he's a dumble soul
> Who don't care for such sports as these.[17]

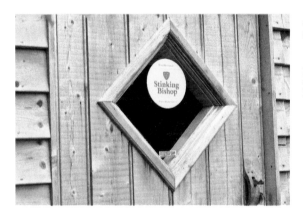

Above: Charles Martell, Dymock, Gloucestershire. (© Nick Kay)

Left: Cheesemaking room at Charles Martell, Dymock, Gloucestershire. (© Nick Kay)

Britain's official smelliest cheese also has its origins in Gloucestershire. Stinking Bishop in name and nature continues to be manufactured on the site of where it is considered to have originated, at Hunts Court Farm, Dymock, home of cheesemakers Charles Martell and Son Ltd. Cistercian monks were believed to have made the cheese in the village of Dymock. The name itself has numerous sources and was patented by Martell's in 2006. It may refer to the insect of the same name, which once plagued parts of England during the mid-1800s. When crushed, the said bug omits a violent stench apparently.[18] Stinking Bishop is also a perry pear and Charles Martell wash their cheeses in the juice. According to the cheesemaker's website, the pear is named after an obnoxious nineteenth-century farmer called Frederick Bishop, nicknamed 'stinking' for his bad temperament.

Food and Drink on the Streets:
Then and Now

Gloucestershire had thirty-four market towns during the Tudor and Stuart era and all except five of these were founded prior to the era of the Black Death, with at least seventeen of them established before the reign of Edward I.[1]

More than most counties, Gloucestershire is known for its markets and food tourism, which are firmly rooted in its early identity. Many Cotswold towns have retained their markets, fairs and fetes, with food centred at the heart of them.

Eastgate Market was built by the Gloucester Corporation in 1856. During the 1930s the type and number of stalls you would have had access to was very diverse. As the *Gloucester Citizen* noted in 1932, Eastgate Market was a place where you could purchase anything from 'a packet of pins to a weekly joint'. (That's a large piece of meat, not a cigarette containing cannabis.) Traders, among others, included Whyhams fruit and vegetables, Goddards fancy goods, J. Fletcher's Hardware,

Moreton-in-Marsh Market House. (© Emma Kay)

Local meat products from nearby Hinton Marsh Farm, trading in Gloucestershire. (© Nick Kay)

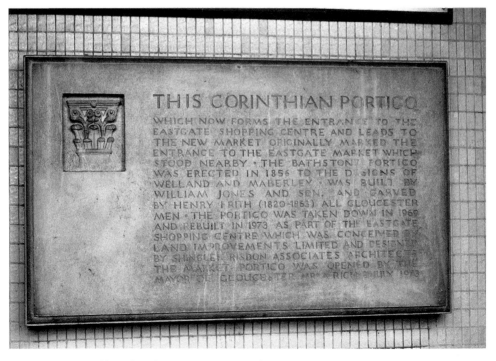

Gloucester city's old marketplace portico memorial. (© Nick Kay)

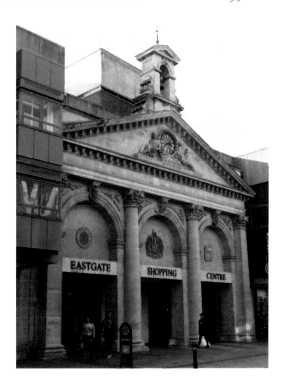

Right: Entrance to East Gate Market, Gloucester. (© Nick Kay)

Below: Percy Langley's butcher's stall, East Gate Market, in the 1950s. (© Philip Langley)

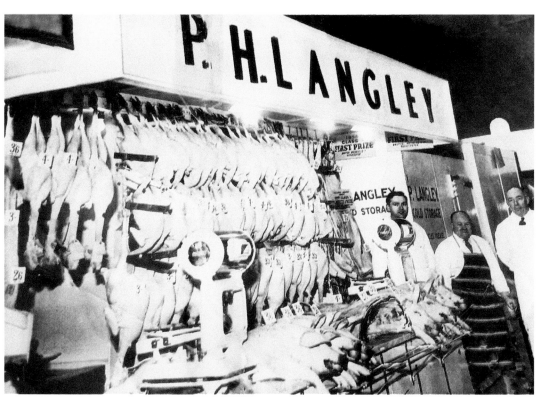

J. Embling's confectionery, Peacocks' household goods and a choice of at least six butchers, including P. H. Langley. Philip Langley is Percy (of the P. H.) Langley's son. His father established the butchery in the 1930s. By the 1950s Eastgate was still a thriving, vibrant place. Philip recalls there being some six butchers, nine greengrocers, five fishmongers and a lady called Peggy Stange who sold cockles, mussels and whelks. 'Peacocks occupied most of the centre of the Market selling anything from a penny whistle to carpets, clothing, kitchen wear – don't forget in those days there was no plastic so everything was metal, we dreaded when a customer bought their child a tin drum complete with sticks, banging away, parent telling them to shut up, having bought them a TIN drum!'

The market manager was a Mr Jobbins, who came by train from Bristol every day. He wore a bowler hat and pin-striped trousers, complete with neat moustache. He sounds like a character straight out of Reginald Perrin to me. (And yes, I am aware that there is a whole generation who will not understand that reference). When one of the market workers had a birthday, the 'Market Choir' would treat them to a personal serenade of Happy Birthday in front of their stall, while all the customers would join in. The Women's Institute had a stall in Eastgate that they managed two days a week. On days when they were closed, one of the fishmongers would brew a large pot of tea in the morning and set it up on their stall. It became a regular popular meeting place for stallholders and even the local police to drop by for a chat and some refreshment.

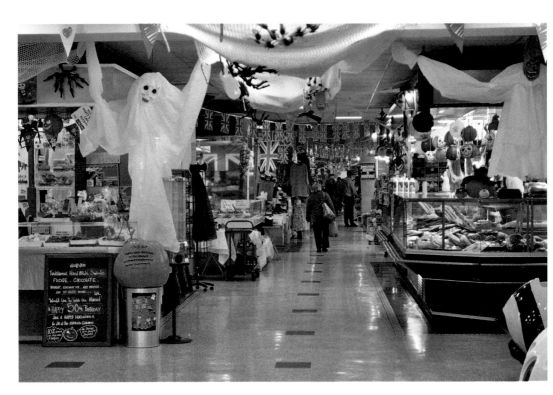

Interior of East Gate Market in 2018. (© Nick Kay)

Picture of old quarter of Gloucester City in 2018. (© Nick Kay)

Philip recalls the physical elements of the indoor market with its vented glass roof, kept permanently open in the summer. The council applied whitewash to try and keep it cool. There were three rows of these glass roofs, running the entire length of the market. It was a very cold structure in the winter with no form of heating. If it snowed the snow would blow in through the vents and land on top of the stalls. When it thawed the water would run down and the lights would explode, often hurling all the dirt from the roof onto the butchery counter. The eggs would frequently crack and freeze onto the marble slab. Fan heaters used to be brought in by the stallholders to try and prevent the meat from freezing. I would love to know what environmental health would think about all that today!

The old marketplace was refurbished to make way for a new site, which reopened in 1968. It remains a popular shopping destination with a variety of retail units. There are plans to see part of Eastgate turned into an innovation centre and a national hub for virtual staff and robotics, which given its heritage as such a people-focused enterprise, seems somewhat sadly ironic.

In nearby Cheltenham, local man Tony Poulter talked at length about the town's Market Street market: 'The town market took place on a big site, next to the abattoir. If I was off school my mum would take me with her. Many of the stall-holders would give me samples of food. It was a great place to buy meat pies from, though looking back – the contents would have been a little "suspect". The stallholders would always be in the same "pitch", so that they could be easily found. There was a strong smell of cabbage around

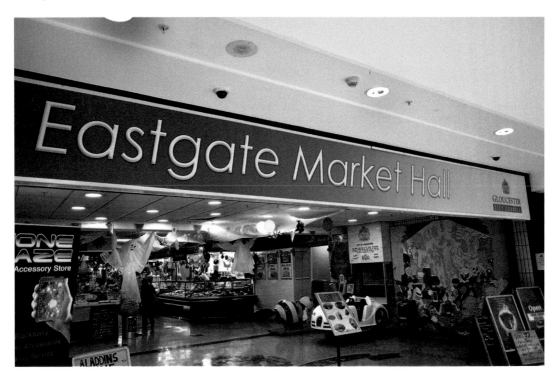

Above: Inside East Gate Market, 2018. (© Nick Kay)

Left: Local produce. (© Nick Kay)

the vegetable stalls and you could buy large sacks of very dirty potatoes. Sometimes after market day I would have an apple to go to school with and at playtime, boys would line up for the core, they were so hungry. Apple cores bought me many friends.'

Katy Blake, who now lives in Bradford but grew up in Cheltenham, remembers her grandmother, Kitty Ursell, who lived in Great Western Road, taking her to Market Street in the 1960s. She recollects, 'We enjoyed browsing round all the stalls but we'd always end up at the stall that sold toffee in large trays. The stallholder had to use a hammer to crack the toffee, which was then placed in a small white paper bag. I thoroughly enjoyed this sticky treat even when the toffee invariably got stuck to the paper.'

Stroud Market.
(© Nick Kay)

Maz Barchus fondly looks back at the Market Street market in Cheltenham too, as 'the best!', with its 'fruit veg meat clothes toys shoes cards kitchen stuff China teas ... market men trying to bag a bargain, Dell and a Rodney stylee! Cakes sweets too and always an ice cream van from Cotswold Dairy. There was always a salesman selling bales of towels or bedsheets and always a new kitchen gadget being demonstrated! Always lots to see and hear and smell too if you were right at the bottom end nearest the animal livestock pens where farmers gathered... There was no other market like it for miles around, so everyone went to it and met up for a natter.'

Stroud hosts one of the most popular farmers' markets in the UK, the marketplace having had a presence in the town for centuries. There is a record in 1650 of a John Bond taking a lease out for 'All those standings, Pantices, shambles and stalls, in a place called the Pitching, all pickage (pitches) and stallage there, all benefit of stalls and standings in the said place called the Pitching; except the standings adjoining the house of Nathaniel Gardner and under the market-house' for a cost of six pounds and ten shillings a year. Bond would then have rented out the stalls to traders and regularly collected tolls from them.

Following every Good Friday from the mid-1700s and for many years after, a series of twenty lectures were delivered daily during market days, given by local clergymen designed specifically to capture the market-goers and traders of the time. In fact, the founding father of Methodism, John Wesley himself, lectured in this very location.[2] Today the food market is held on a Saturday, but traditionally Friday was always market day in the town. You can also now order local produce online from Stroud market traders, if you are unable to attend on the day.

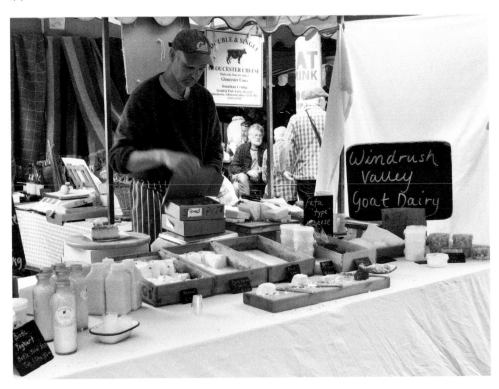

Above: Stroud Market. (© Nick Kay)

Below: Stroud Market sandwich board. (© Nick Kay)

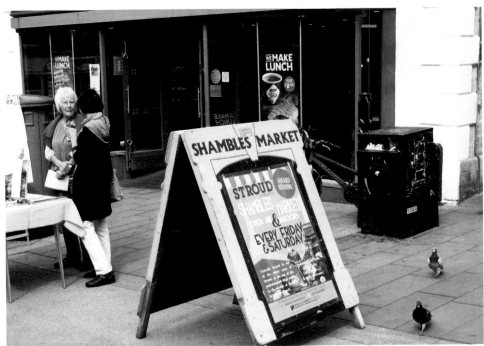

The old Market House, Stroud, mid-1800s.

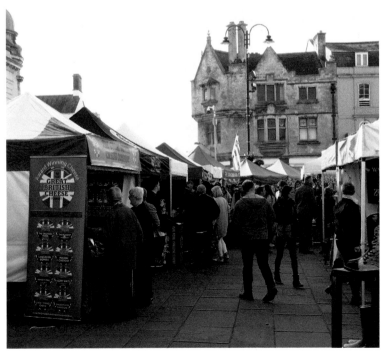

Above: Gloucestershire seasonal vegetables. (© Nick Kay)

Left: Cirencester Market, 2018. (© Nick Kay)

The hub of the market used to be the Old Market House, built in the 1500s, which also served as the town hall, with the predominant market trade belonging to butchers and dairymen/women. Now, the weekly market is a vibrant in and outdoor rich mix of cheeses, fruit and vegetables, fish, charcuteries, poulterers, drinks, preserves, bakers and multi-ethnic delights.

Cirencester Market's profile was raised during the 1960s when Alice Mary Hadfield published her popular adventures *Williver's Luck*. Praised for its historical accuracy outlining the Industrial Revolution, the novel is a boy to man story, following the life of Tom Williver growing up in the eighteenth century. He starts his journey at Cirencester's weekly market, where he is robbed of the money he acquires from the sale of his mother's butter and cheeses on the dairy stall by a couple of confidence tricksters. He describes the two rows of tiny wooden and plaster houses and shops dominating the middle of the marketplace, which is alive with people and animals filling every square foot. The following description of Cirencester Market was published in Kelly's Directory of Gloucestershire, 1914:

> The market day is Monday, when a great deal of corn is usually sold. The Corn Hall was erected and opened in the year 1862, and adjoining is a butter and poultry market. The market for live stock is held in the Cattle market on the Tetbury road, the first and third Mondays in every month; it is an inclosed market, contiguous to the railway sta-tion, and the property of Earl Bathurst. Two 'mops', or statute fairs, for the hiring of ser-vants, are held on the Monday before and the Monday following Old Michaelmas day; a fair, called Holland fair, is also held in November: the fairs are held in the Market place, excepting the sheep fairs, which are held in the Cattle market.[3]

There is a rather disturbing event recorded in Cirencester Market in 1814 of a 'female with a halter round her neck' being exhibited for sale. She is described as being from Rodmarton, the wife of John Ratcliffe and the mother of eleven children, purchased as 'a bargain' by a young man for two shillings (around seven or eight pounds today). The story made me feel both uneasy and eager to know more about the fate of this poor woman.[4] Despite the abolition of slavery not being passed until 1833, it is alarming to think that acts like this were still taking place so publicly. Was she being shamed and punished? Or were the family simply in dire need of money? Although it would not have been unusual for people in certain strata of society to sell their children back in the Georgian period, one has to ask why the wife and mother and not one of the eleven children? I suppose we will never know. The article does go on to confirm that both parties involved in the transaction were taken away by magistrates, but for the whole activity to get as far as a sale is in itself a reminder of darker times.

Tewkesbury once hosted two markets, one on a Wednesday for corn, cattle, sheep, pigs, butchers, poulterers and dairies, with the Saturday market selling more generic goods. It was a thriving commercial town that made full use of its nearby rivers to transport goods back and forth. The marketplace holds a bloody legacy as the supposed location of the execution of Edmund Beaufort during the Wars of the Roses,

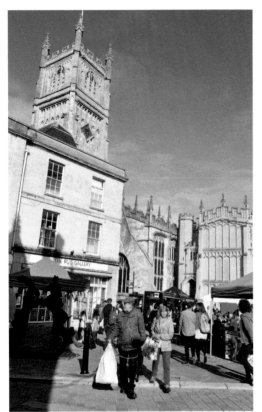

Above left: Cirencester Market, 2018. (© Nick Kay)

Above right: Tewkesbury High Street, 2018. (© Nick Kay)

who was forced out of his hiding place in the abbey by the Yorkists during the Battle of Tewkesbury.[5] Today cakes, breads, preserves, fruit and vegetables and many other farmer's market delights pitch up, not in the town's old original market house with its romantic Doric columns and pilasters, but in the main car park, every second Saturday of the month.

Stow-on-the -Wold marketplace was also the scene of a bloody battle in 1646 – the Battle of Stow, or as some call it, the first English Civil War. Its bustling farmer's market is now one of the most visited in the Cotswolds.

Nailsworth formerly boasted one of the county's biggest cattle markets until its closure in 1931. The word Nailsworth is actually a derivative of the Anglo-Saxon for 'wool market'. The town was once an important centre for wool production, dating back as early as the twelfth century. Wotton-under-Edge had a similar dynamic, transforming into a very popular produce market during the 1930s. The town of Minchinhampton has retained its original market house, built in 1698, which delivers a farmer's market every Thursday. Historically, nearby Tetbury became a more popular market and since the mid-1700s Minchinhampton Market House has served more as a social centre for

the local community, most famously with a performance from the acclaimed actress Sarah Siddons. Mrs Siddons (*née* Kemble) allegedly once lived in the Forest of Dean, before securing her place as one of the most legendary actresses of all time.[6] Another Gloucestershire market town with theatrical connections is Dursley, where William Shakespeare is reputed to have once briefly lived. Certainly, there was a Shakespeare family seat in the area for several hundred years and his works depict an intimate knowledge of the area.[7] If he did indeed live and even perform some of his plays in Dursley, he would have attended the market, which was once held every Thursday. Today it occurs once a month between March and December. The 'Venice of the Cotswolds', Bourton-on-the-Water stages its market on the fourth Sunday of the month.

There are various references to some of the more colourful Gloucestershire street sellers of the nineteenth and early twentieth centuries to be found in the archives, including George Cox, who was known as a 'persistent obstructionist', often leaving his sweet cart in the middle of the High Street in Cheltenham,[8] and Betty Brown, a prominent tripe seller and huckster based near the George Hotel in Stroud.[9]

Known as a local fruiterer and shop owner in Gloucester, there are sundry tales around Hubert Artus. By 1908 he appeared in court for failing to pay for a horse bought from a fish and fruit merchant, at a cost of seven pounds. Some eight years later he was accused of stealing a bicycle and was implicated by his own father-in-law, who also turned out

Gloucester street scene. (© Nick Kay)

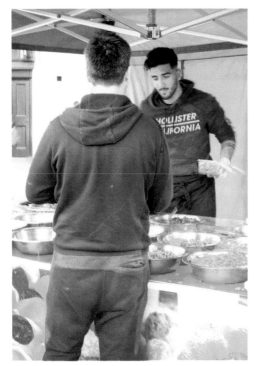

Above left: Gloucestershire modern-day street food seller. (© Nick Kay)

Above right: The famous actress Sarah Siddons, 1810. (Courtesy of Yale Center for British Art, Paul Mellon Fund)

to be guilty. A year later, he was charged with purchasing an orchard and then failing to pick the fruit or make any form of payment for it. On this occasion Artus was found guilty and ordered to make a payment of nine pounds and five shillings to the plaintiff.[10] By 1919 and at the age of thirty-two, Artus was given bail during a complicated case in which he was found in illegal possession of a stolen motorcycle and accused of stealing ten cases of whisky, alongside six cases of brandy. The story and trial were widely covered in the local press as it involved a lot of rather unsavoury local characters.[11] He was found not guilty on several accounts, but guilty in the case of the motorcycle (found on his premises). Artus was sentenced to nine months in prison with hard labour.[12] Three years later Artus was in court again for non-payment of wages to his staff. In 1925 we once again hear about Hubert Artus obstructing a footpath outside of his shop premises in Barton Street by advertising and promoting his products, in particular crates of oranges. He had been warned on several occasions by the local police, but continued to persist. For this crime he was fined thirty shillings.[13] In 1928 this reprehensible character was summoned to court again, for failing to produce a dog licence. By this time, he was running a fried fish shop in the same street as his old fruit shop, which suffered a fire in August 1928. The stories just keep going, including car crashes and marriages. I have so many outstanding questions about Hubert. Local man Philip Langley remembers an Ivor

Barton Street, Gloucester, former location of Hubert Artus' shop. (© Nick Kay)

Artus, who lived in Belgrave Road, operating as a cut flower wholesaler. His father was affectionately known as Boo. Hubert Artus had moved from Barton Street to Belgrave Road in later life, so whether there is a connection or not, for now, remains speculative, but for me he resonates as one of Gloucester's most colourful of traders.

Hubert Artus initially lived and worked in Barton Street, Gloucester which was also the location of the Barton Fair – a combination of cheese, sheep and pleasure/travelling fair in rotation. The Barton Fair was relocated in 1904 with the introduction of the tram system, but it remains a historically significant aspect of Gloucester's cultural heritage. There is a strange case of murder connected to Gloucester Cheese Fair, when in 1873 Charles Edward Butt was sentenced to death for the murder of Amelia Phipps, a young woman he had been courting for some time. She refused Butt's invitation to accompany him to the fair, which sent him into a frenzied rage and he shot her. Having already been rejected once by Phipps, Butt had acquired a gun and visited her a second time to ask the same question about attending the Cheese Fair together. Once again, she rejected him and was killed for her rebuff.[14]

The year 1798 appears to have been one of the most notable years for cheese sales at Barton Fair. It was commented in 1798 that demand for cheese had been poor and its value somewhat diminished in previous years, but in 1798 cheese sales at the fair were at an all-time high, with the best cheeses fetching thirty-eight to forty-two shillings – relative to around £100 today.[15]

Local residents Philip Langley and Keith Gatfield both remember Manley Wixey, a heavy-weight boxer and minor celebrity who ran a small holding off Oxstalls Lane, Gloucester. He was frequently seen sporting wellingtons and/or a black eye.

Left: Barton Street, Gloucester, location of the famed Barton Fair. (© Nick Kay)

Below: Tredworth High Street, home of Manley Wixey. (© Nick Kay)

He grew produce on his own land and went around the town selling it out of his van to passers-by and the local pubs. Philip recalled that he could often be found in the Hope Inn in Barton Street as he did his rounds. In 1939, at the height of Wixley's fame, he was running a greengrocers in Tredworth High Street and was charged with drink driving following a boxing match when crashed into another car under the influence and was taken directly to the station. Wixey was fined one pound, ordered to pay costs and had his licence revoked for six months.[16] He seems to disappear from public record after this, but was obviously, as Philip Langley recalls, still selling fresh produce into his later life.

Many local Cheltenham and Cirencester residents remember the travelling Corona van and Tartaglia's ice-cream van (you can read more about the Tartaglia family in the next chapter), as well as the travelling Co-op mobile grocery shop that parked on the corner of Orchard Avenue and Orchard Way. Then there was Gloucester tripe dealer Charlie Blease and his brother, who were well known for their 'Trotting' races in the city, sitting on a frame and driving the horse forward – a bit like a chariot – a sport often associated with the traveller community trotting races today. Several locals also remember the Polish food seller Mr Idzikowski, who sold cakes, fruit, sweets, krakowska, wiejska and kabanos out of the back of his van. This was around 1960, proving that communities were becoming more diverse with their tastes as a consequence of post-war immigration.

A few folk remembered Gordon (Charlie) Knipe, a much-loved local character who used to ride his Wall's ice-cream tricycle, a job he started in 1933 and continued right up until the 1970s. Bill Hatcher reminisced about how 'he [Knipe] used to cycle around on a trike (two wheels at the front, one at the back and with an insulated Walls ice-cream chest built in) every Sunday. He used to wear a white coat and (I think) black peaked cap Walls uniform. He had a route and would stop off at Escourt Road, London Road, Barnwood/Elmbridge. Dad said these guys were at one time seen across the country but this particular man was the last one.' Charlie Knipe was interviewed by Chris Tarrant for ATV back in 1974, with comedic consequences. One of his standard ice creams cost just ten pence that year.

No one locally seems to agree on where the best place was to purchase fish and chips in the Cheltenham and Gloucester area. Some swore by the Regent, while others, like Derek Bond, preferred Culpeper's 'the fish and chip place in Charlton Kings, where we used to stop on the way back from cub scouts – stuck your finger through the newspaper wrapper to make a hole, cut potatoes lying in an old bath on the customer side of the counter'. Carole Sharpe claimed that 'Bolton's' on the corner of Southgate Street in Gloucester made the best fish supper. Andy Aubrey agreed, when reminded that you could buy four chips on a fork for an old penny. But it is Mark Phillips who provides perhaps the most romantic of recollections: 'Where Over Farm Market is now, back in the '70s, used to be the depot for Fleetwood Fish and Brixham Fish. Articulated lorries known as "Trunkers" would arrive mid-evening and distribute their load into smaller 10-ton lorries. My father Bill Phillips (the watch repairer) drove for both companies, and would set off around ten at night and head up to Kidderminster before going around the West Midlands including the Bull Ring Market in Birmingham. I have many happy memories of going with him on a Friday night as a boy. Free fish

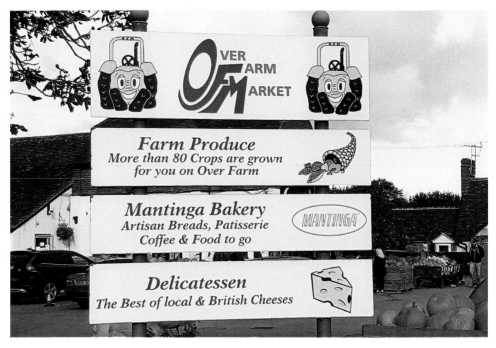

Over Farm Market, 2018. (© Nick Kay)

Over Farm Market, 2018. (© Nick Kay)

and chips in "Kiddy" before the chip shop shut and returning through Hartpury in the morning as the sun came up over the city!'

For others, faggots and peas, a popular convenience food of the past that has since fallen out of fashion, were more of a pull than the chip shop. There is an interesting case of exemption from the army during the First World War when a 'refreshment housekeeper', Mr Colwell from Gloucester, went before the courts to apply for exemption in lieu of the fact that the faggots and peas he sold were an essential asset to the local community. He made in excess of 44,000 faggots a year to help feed the town.

The presiding judge enquired about the nature of faggots and asked Mr Colwell to describe them to the court, which he did, stating that they contained fried liver, onions, seasoning and bread, likening them to haggis. The case is recorded as having a great deal of laughter throughout the proceedings, but Mr Colwell was granted exemption on the condition that he joined the Volunteer Training Corps.[17]

Richard Willis looks back to a time when clearly people were far less concerned about the safety of unaccompanied children, as he remembers being around aged five and being sent by his aunt to a pub on the corner of Regent Street in Gloucester, armed with a pudding basin to collect home-made faggots to bring back for supper.

Ask anyone over a certain age in Gloucestershire and they will all remember elvers, the fishing of them, eating of them and the pure joy that they seemed to bring to so, a product that became internationally adored. Here are just a few soundbites of those many stories attached to this most highly prized of regional eels:

We lived on Matson estate and I can remember someone coming round selling elvers using beer mugs as measures. I think they were wheeled round in an old pram. (Marion Hunt)

My Dad used to put a white tea towel over a chair out the front of our house and this indicated we had elvers for sale. This would have been in the 1950s. (Dorothy Wallace)

Elvers were very popular for years … during the war I remember a man with a cart would go up and down the streets with the elvers and the women would come out and he would sell them by the pint and often some would escape and be wriggling about in the gutter. They were often advertised outside people's houses all round Gloucester. The last notice of elevers I remember was in St Michael's Square late 1970s. (Pamela Wright Brogan)

I remember sitting on the step while my Gran, who was a big lady, sat on a chair on the pavement with a tin bath full of elvers selling them by the pint and I kept putting my hand into the bath and eating them alive. Mum said they were wriggling on my chin! That would have been around 1952 in Upton Street. (Judy Darch)

Another slimy edible commodity was that of the snail. Lorrain Keightley's grandmother owned a pub in Gloucester during the 1920s and '30s and together with her father, they would collect snails locally, boil them up and sell them to the customers. Others remember going snail collecting with buckets as children and selling them on to the pubs to earn a bit of extra pocket money. I'm not sure I'm quite ready to trade my potato-based bar snacks in for snails, but I do remember visiting a pub as a child to have dinner many years ago with my family in Devon. The main attraction on the menu was snails in garlic. So perhaps this tradition is not so far removed after all.

Producers and Cooks

The 'Fabulous' Baker Brothers, Matt Weedon, Chris White , Mark Block, David Everitt-Matthias, Charles Smith, Jon Howe, Andrew Kojima, Emily Watkins, Iain Dixon, Kuba Winkowski , Nick Deverell-Smith, Ian Percival, Gareth Fulford, Tom Kerridge, Ryan King, Bob Parkinson, Mark Reid, Wayne Sullivan, Chris Underwood and many others besides, are all significant names in the food sector who are currently making, or have previously made, their mark in the county or on its borders. Gloucestershire is home to several Michelin Star restaurants, numerous large-scale producers and food specialists. The county's food businesses are reflective of its food heritage, from Hobbs House Bakery to the ever-expanding Cotswold Cheese Company, offering a choice of over 100 farmhouse and artisan cheeses, Daylesford Farm's organic corporation and the multi-award-winning fish emporium, William's Food Hall, to name a few. There are within this pot numerous lesser-known heroes like the Prout's of Standish Court Farm, who were once county famous for their Gloucestershire cheesemaking skills and Crumps of Tewkesbury who engineered a pioneering sheep rack.

During the seventeenth century Gloucestershire was predominantly a cloth-making county, not one known for farming and agriculture. By the nineteenth century the docks provided a wealth of import and export trade and the small businessman and shopkeeper thrived across the county, a trend that continued well into the 1950s and 1960s, before the repercussions of mass consumerism and technology

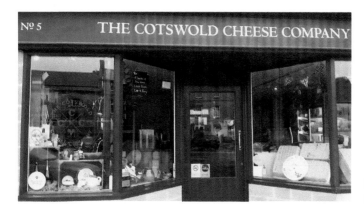

Cotswold Cheese Company. (© Emma Kay)

Above: Local independent cheese seller. (© Nick Kay)

Right: Mulberry Restaurant at the Manor House, Moreton-in-Marsh.

Café René, one of the county's numerous independent bars/restaurants. (© Nick Kay)

took hold. In Painswick alone there were eight grocers, five butchers, three bakers and a cheesemonger listed in the 1820 Gloucestershire Directory.[1] Today many of Gloucestershire's towns are struggling with the demise of the High Street, but where there's old tradition and genuine craftmanship, there's often new hope.

BUTCHER'S AND BAKERS (NO CANDLESTICK MAKERS)

The first reference I can find for Daniel Smith Snr – his sons Daniel and Jesse being fourth-generation smiths of Jesse Smith Butchers – is for the payment of annual rent amounting to twenty-four pounds and eight shillings, for the 'two houses and shops, with slaughter house, stable and gardens in Black Jack Street', which he occupied together with a Mr Charles Cowley, a hatter.[2] In 1883 Daniel Smith Jnr, who was originally in business with his brother Jesse Smith, left Cirencester to relocate to Hastings with his

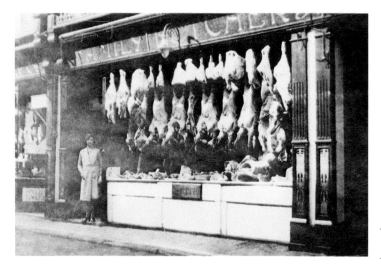

Jesse Smith Butchers, Cirencester, 1932. (© Jane Richardson)

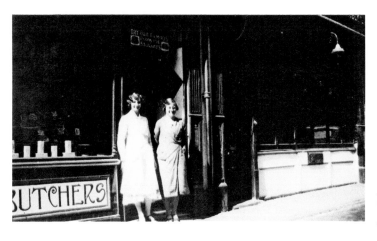

Jesse Smith Butchers, Cirencester, 1933. (© Jane Richardson)

family. But Jesse stayed behind and continued to build up the local meat empire. Today, this includes multi-award-wining butcher's shops, farm shops and a bistro. They remain one of the oldest, most successful family businesses in Cirencester. Many residents of Cirencester can recall their ancestors working in the original butcher's shop, still located in Black Jack Street, like Jane Richardson, whose grandmother, Marjorie Day, was photographed in her overalls, outside the now iconic local shop during the 1930s.

Food businesses were often family based in the past. Loz Thorne's great-grandfather, Bernard Dolphin, ran a bakery in the village of Longborough, near Moreton-in-Marsh, called Dolphin & Son. They provided baked goods for all the local events and at one time that is how every business would have operated – as the main supplier for the local community. Bernard's wife Sarah was the local postmistress and quite a character in the community, not retiring until she was ninety-two. Bernard and Sarah lost their son (also Bernard) during the First World War, in 1917.

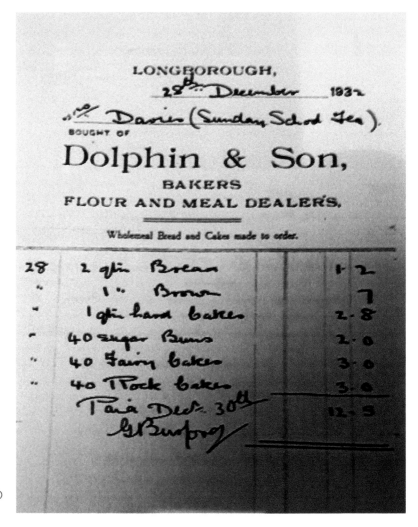

Dolphin & Son Bakery, Longborough. Receipt for Sunday school tea, 1932. (© Loz Thorne)

I have mentioned former Cirencester bakeries Ann's Pantry, Sparkes and the Blue Door. One business that continues to fight the ongoing threat of high rents, rates and increased competition from the big commercial stores is AJ Whiddetts Bakery, a family-run enterprise trading for over thirty-five years, which bounced back from closure a year or so ago, to reopen successfully in an alternative location in the town.

Many small family-run businesses continued to rely on the food and drink industry across Gloucestershire well into the twentieth century, families such as Jim Ball's grandparents who acquired their shop, J. R. Tapp Baker and Confectionery, around the 1920s in Lower High Street, Cheltenham. He described it as 'a shopfront window, dressed with cake stands and trays of bread, as you entered the shop, the counter was on your right, and on that counter was more cakes, pies and slab cakes, and the children's corner (sweets), you then walked up some steps reaching the living quarters, a door leading into the parlour and the small kitchen, just before you entered the parlour, you had stairs which led up to three floors where the bedrooms were situated, then you had the stairs which went down to the cellar which ran under the house, you went out the back kitchen door, this led to the stables where gramps kept the horse and trap for his ginger beer run, then at the bottom of the garden was the bakehouse, this had to be seen to believe it, that's where gramps worked when he was not out and about selling ginger beer'. In the main, the shop stocked home-made bread, currant buns,

Jim Ball's grandmother. (© Jim Ball)

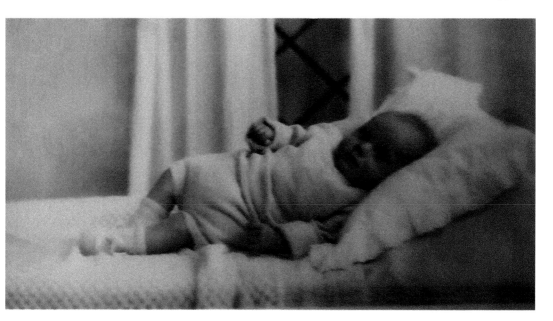

Jim Ball age three months. (© Jim Ball)

jam tarts, rock cakes and trays of meat pies that served the local factories. The pies were made from meat supplied by the local butcher's shop two doors down, the flour for the pastry from the local mill and the yeast from the United Yeast Company in the High Street. All the sweets, cigarettes and other commodities were bought wholesale from 'Charles Dickens', also just up the road. It's not often that you find this level of localised providers all utilising each other today, but during the early to mid-part of the twentieth century, this was common practice.

Cheltenham High Street, 2018. (© Nick Kay)

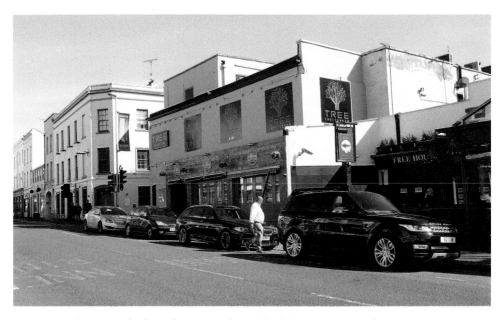

Original site location of Tilley's factory, Bath Road, Cheltenham. (© Nick Kay)

Tilley's crumpet enterprise started during the First World War, when Thomas Tilley walked around the streets of Cheltenham with a tray of crumpets, touting his wares. Tilley's was producing in excess of 160,000 crumpets every day, with a daily batter consumption of 7 tons when the company moved to their new premises, Nos 12–14 Bath Road in 1946.[3] It continued to thrive for around sixty years before a large-scale trade union dispute in 1977 forced its closure.[4] Tilley's also made very popular ginger and brandy snaps during the summer months, when production of the crumpets ceased until the colder weather set in. Travellers on the upper deck of the bus to Leckhampton, a district of south Cheltenham, were regularly treated to the tantalising view of crumpets rolling along the conveyor belt, to be seen through the window when the bus stopped right outside the factory. Apparently, Tilley's received its fifteen minutes (or rather a few seconds) of fame when it featured in the 1968 film satirising the English public-school system, *If*. A reflection of the premises can be seen briefly in the window of a motorcycle shop.

Beau's Bakehouse near Stroud bake on-site and then distribute to local shops and cafés. The business pays homage to owner Jacqui's grandmother, Beau, who owned and ran a 'cake kitchen' in 1920s New Zealand. Her ingredients are on the whole all sourced locally, including flour from the historic Shipton Mill, near Tetbury, which claims to have been milling flour since the eleventh century. During the 1800s the mill was owned by Daniel Tanner, who was quite a revered and principal farmer in the community. Not only did he almost entirely sever his arm thrashing corn with a steam engine in 1865, but he also died at the mill, around twenty years later following complications from lying out in the sun for too long. His death was covered in the local press in some detail and it was said that his demise 'cast a gloom over the villages

Above: Shipton
Mill, near Tetbury.
(© Nick Kay)

Right: Shipton Mill. (©
Nick Kay)

of Long Newnton and Shipton Moyne and the town of Tetbury'.[5] Halls Bakers also claim to use Shipton Mill flour, as do Hobbs House, who stock Shipton Mill flour in their shops. Established at the turn of the twentieth century by John Hall and his son Edward, Halls Bakery originally served the village of Minchinhampton and its surrounds. The company grew beyond its means and now operates out of a large wholesale business, with its corporate office based in Stroud. Like Halls, Hobbs House Bakery started in a village setting, that of Down Ampney. The Herbert family boast some five generations of bakers (and a butcher). They call themselves 'a true family business', and that they indeed are, continuing to apply traditional techniques such as their amazing sixty-three-year-old live yeast culture that is fed daily like some kind of perpetually hungry beast and added to their famous sourdough loaves. Many readers may best associate Hobbs House Bakery with that enduring of television duos *The Fabulous Baker Brothers* – aka Tom and Henry Herbert. Although technically

Above: Shipton Mill flour on sale in Hobbs House Bakery. (© Emma Kay)

Left: Halls Bakery shop, Cirencester. (© Nick Kay)

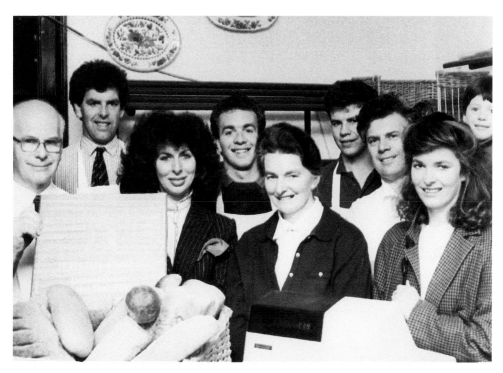

Above: The Herbert family, winners of 'Family Bakers of the Year', 1988. (© HobbsHouseBakery)

Below left: Tom and Henry Herbert, aka the Fabulous Baker Brothers. (© HobbsHouseBakery)

Below right: Henry Herbert interview, September 2018. (© Emma Kay)

Original Down Ampney bakery, 1920, where Tom and Mabel Herbert first started the business. (© HobbsHouseBakery)

one is a trained butcher and one a baker, they are both the backbone of Hobbs House Bakery, now a small chain of independent shops. I was lucky enough to acquire an interview with the delightful Henry Herbert, whose enduring passion for his family's busy and the county is both hugely warming and somehow terribly reassuring in terms of safeguarding the family's tremendous legacy and reputation across Gloucestershire.

The now well-documented story goes that Henry's great-grandfather, Thomas Herbert, started out as a blacksmith. He struggled after being made redundant and traipsed all round Bristol looking for an apprenticeship as a baker, on the advice of his wife Mabel, whose father was a successful baker. What he ended up with was an entire bakery, out of which he started baking the very next day. The couple also established baking premises in their home village. Since then the business empire has continued to cover both the Cotswolds and Bristol, with David Herbert, Henry's grandfather, opening premises in Montpelier in the 1960s, during a period when immigration to the city was at an all-time high, providing him with the opportunity to create a multitude of baked goods to suit this diverse new market.

Many local people remember Philip Herbert, Henry's great-uncle and one of the original six Herbert children of Tom and Mabel. He made many cakes for special occasions for the local Down Ampney community, including Elizabeth and David Beaumont's wedding cake, before moving to Bristol to carry on the baking there. In fact, he wasn't the only Herbert to do this, as Henry claims at one stage there were some twenty-two shops in Bristol linked to the Herbert family dynasty. It was to one

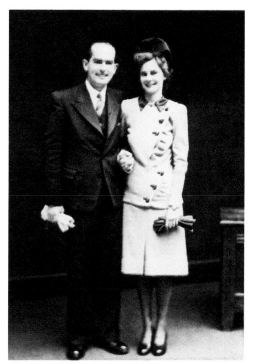

Above left: Phil Herbert and Grace Wood on their wedding day. (© Elizabeth Beaumont)

Above right: David and Elizabeth Beaumont on their wedding day, enjoying Phil Herbert's cake. (© Elizabeth Beaumont)

of these bakeries that a local Bristolian lady bequeathed her entire estate as thanks for Henry's grandmother Margaret's kindness with bringing her soup and bread over a number of years throughout her illness.

It was Grace Herbert's (also one of the original six children) husband, Leslie Gear, who took on the Down Ampney baton, as well as running a shop in Cirencester, the Pastry Parlour, following the war. But, it was during the Second World War that the Herberts of Down Ampney really made their name as bakers nationally, by contributing to 'Operation Manna'. This was a military exercise that involved food being dropped by aircraft into occupied countries, to help feed the starving communities. Tom Herbert baked the bread, loaded onto planes in the village (which also served as a wartime RAF base) that then fed the people of many isolated Dutch towns.

David Herbert, Henry's grandfather, was a nonconformist and a non-team player, which to his benefit led him to acquire the skills of miller, baker and entrepreneur. These skills were then passed down to Henry's father, Trevor, who bought the premises in Chipping Sodbury, part of which was a butcher's shop, and retained the old Hobbs family namesake in the process – hence the incarnation of Hobbs House Bakery. For a brief period, Henry ran the butcher's shop, which some years later the family leased to an independent butcher and it remains successful today. The Herberts continue to reinvent

Left: David Herbert. (© HobbsHouseBakery)

Below: Henry Herbert with staff at the Chipping Sodbury branch of Hobbs House Bakery. (© Emma Kay)

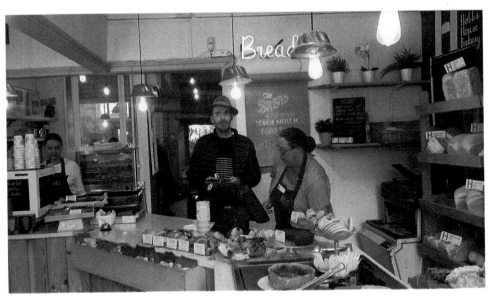

the business and have conducted pioneering work abroad, as well as investigating new ways of working in a more environmentally conscious way. Their recycling policies are innovative and their future commitments ambitious. They have come a long way from the little sponge cakes with jam and coconut that Mabel used to make along with her hugely popular pasties, which, according to twin sisters Margaret Stratford and Maureen (whose mother used to clean for Tom and Mabel at the bakery), you could purchase three or four of for a half penny (around fifty pence in today's money).

DAIRY

Perhaps one of the best-known and biggest food businesses in the world, Wall's Ice Cream was founded in 1786 by Richard Wall. Now owned by the transnational giant Unilever, Wall's Ice Cream once had a thriving presence in Gloucester during the 1960s. It was in fact then the largest ice-cream factory in Europe. The premises were merged with Birds Eye during the 1980s and more recently the empty factory has been transformed into a new business park. Back in the 1960s it was a significant local employer and Gloucester lady Jane Regan who 'used to work on the factory floor packing the green lollies during the long college summer holidays. The best part was earning extra money for "stripping" after everyone else had gone home.' (Stripping was melting the waste lollies down in a bucket then taking all the paper covers and sticks out of the mix, leaving just the liquid, which was recycled.)

Horace Russell also worked at Wall's during the 1960s and between 1959 and 1964 he won 'driver of the year' for the company, as a long-distance distribution driver.

Another annual award handed out to employees was the title of Miss Wall's. Valerie Webb (née Stevenson) started as a junior secretary in the distribution department and won the prestigious title of Miss Wall's in 1969: 'It was a local competition. It was just a sort of beauty pageant, just a few questions as far as I can remember.' Valerie was also one of the first members of staff to brave the latest fashion trend of the 1960s and '70s – which was covered in the Wall's newsletter – by controversially turning up to work wearing a very short pair of bright red hot pants. The Wall's newsletter commented that 'this was the break-through that many fashion-conscious young girls had been waiting for'.

Wall's Unilever premises, Gloucester. (© Nick Kay)

Above left: Horace Russell, winner of Walls Gloucester Best Driver Award from 1959–64. (Courtesy of Sheila Clark)

Above right: Valerie Webb winning 'Miss Wall's', 1969. (© Valerie Webb)

Below: Frampton-on-Severn. (© Nick Kay)

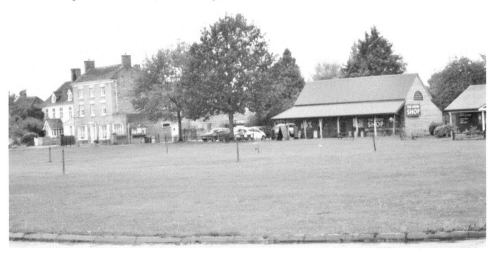

Wall's provided a social club for staff. Former employee Jane Vassallo remembers attending the dances the company organised on a Saturday night and you were allowed to bring along a guest. The club also included an amateur dramatics society, which put together numerous performances.

Cadbury began buying up land in Frampton-on-Severn early in the First World War. The canal in this small village gave it a huge commercial advantage. Cocoa beans entered the port at Bristol and were then sent upriver to Frampton, while local farmers provided the milk to produce a 'chocolate crumb', which was then loaded and shipped up the Severn again to the Cadbury Bournville factory in the West Midlands. The Cadbury factory at Frampton remained open until the 1980s and provided the village itself with recreation grounds, sports fields, a cricket pavilion, tennis courts and social housing among other facilities as a means of safeguarding and nurturing their employees. Cadbury Hall was built by the company during the 1930s as an entertainment venue for the community. It remains as such today, providing locals with regular activities, performances and events.

Dairy Partners of Stonehouse have been producing cheese and milk products for generations. They now sit comfortably in the top fifty businesses based in Gloucestershire. But they are not the only large-scale, commercially successful cheese industry in the county. Futura, located in Dursley, claim to be one of the largest suppliers of Continental cheese to the UK, including halloumi, feta and mozzarella. Cotteswold Dairy started trading in 1938 and remain a significant local and wider national contributor of milk products across Gloucestershire, Worcestershire, Hereford, Wales and Warwickshire. I can totally vouch for their cream; it is delicious.

I interviewed Gordon Tartaglia, whose family pioneered Cotswold Dairy Ice Cream of Cheltenham. Tartaglia's was the other division of the family business, established by Gordon's great-uncle and based in Gloucester. In their heyday, both companies were staggeringly successful and popular. Gordon's great-grandfather and great-uncle came

Cadbury Hall, Frampton-on-Severn. (© Nick Kay)

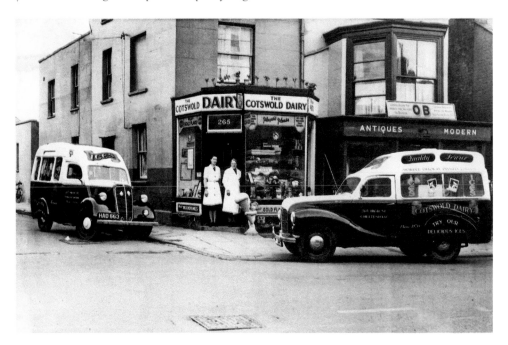

Above: Cotswold Dairy, No. 265 High Street, Cheltenham, in the 1950s. (Courtesy of Gordon Tartaglia)

Left: Site of the former Cotswold Dairy, Cheltenham, in 2018. (© Nick Kay)

over from Italy to Wales during the early 1900s. His sons, Mark (Gordon's grandfather) and his brother Phil moved to Cheltenham and Gloucester respectively, establishing rival ice-cream businesses. Mark and his wife Clara had six surviving boys: George, Ron, Michael, Fred, Phil and Tony, Gordon's father.

Gordon's grandfather originally made the ice cream in a wooden vat surrounded by ice and would take it out to sell on the streets from a handcart. Following the disruptions of the war, Gordon's father and uncles built up a business in Cheltenham. At one stage this included a fleet of eight ice-cream vans, two trailers and around ten full-time staff. Gordon's parents, Tony and Pearl, diversified the business model somewhere in the 1960s to include ice lollies and toffee apples, which they manufactured in local factory

Interior of Cotswold Dairy. (Courtesy of Gordon Tartaglia)

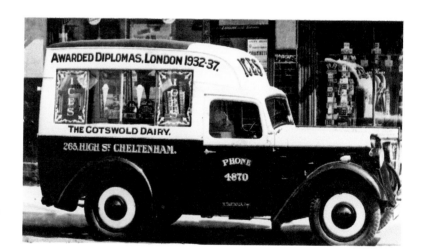

Cotswold Dairy van on its rounds. (© Gordon Tartaglia)

premises. Various uncles and aunts managed the other aspects of the business. Gordon managed two vehicles and pitches at Sandford Park and the lido, while his parents ran successful shops in Cheltenham, as well as gaining the monopoly for Pittville Park.

The recipes and skills required to make the ice cream were all handed down from generations of ice-cream makers and remain a family trade secret today. All the ice cream preparation was completed by family members and a few very close loyal assistants who were employed with a strict remit to protect the recipe.

Ice cream literally runs through the Tartaglia veins, as Gordon admits that he was given a preparation of ice-cream mix in his feed bottles as a baby. Not only that, but his grandmother went into labour while on one of her ice-cream rounds with a hand truck and the baby had to be delivered there and then. Now that's dedication.

Boselli's ice-cream
advertisement,
Gloucester, 2018.
(© Nick Kay)

Gordon married into Tarr's of Bristol when he met his wife Sue at an ice-cream manufacturers' dinner and dance event. Tarr's are another long-standing family ice-cream company, based in Bristol.

One of the most visual reminders of the Tartaglia family business by the public were the numerous vans that scoured up and down Gloucestershire. Gordon's grandfather refused to wholesale their products, so ice cream was only available from the vans or directly from the dairy. When I asked Gordon what were the most popular flavours, he answered vanilla, particularly when in cornets. Many families would also take large tubs across to the vans and buy in bulk for the freezer. The Cotswold Dairy Ice Cream Company was sold to local rival firm Winstones in the 1990s, along with the original recipe. Founded in 1925, Winstones is another prestigious family ice-cream manufacturer, who continue to make fine iced treats from their premises nestled in the Stroud valley.

At the height of its success, Gordon's side of the Tartaglia business won a variety of awards over a number of years and became synonymous with quality and reliability. He still remembers the intense smell of vanilla in his clothes and hair and denounces much of today's ice cream as mass produced and substandard.

So, what's the key to a good ice cream? Apparently, the best ice creams can only be kept for up to two to three days. I would speculate that provides some indication of the lack of sugar and preservatives to be found in ice creams of the past. There are many local ice-cream providers operating in the county today. Those of the past have, in some cases, left a reminder on the landscape, but sadly not in the archives.

FRUIT, VEG AND GROCERY

Thomas Twining is perhaps one of England's greatest tea merchants and despite moving to London as a young boy in 1684, his place of birth was actually in Painswick. Originally from a family of weavers, it was out of financial necessity

that the Twinings relocated to London. While Thomas went on to make his mark in beverage history outside of the county, it was fellow local tea importer Edward Wathen Fyffe, born in 1853 in the small Gloucestershire village of Woodchester, who would also succeed in a very different area, by establishing one of the biggest tropical fruit suppliers in the world.

Today Fyffes continues to trade as part of its merger with the United States Chiquita brand. Fyffe began shipping bananas from the Canary Islands to London around 1888. Inspired by the quality of the fruit and its comforting properties while nursing his wife Ida through tuberculosis, his business became such a rapid success that he pulled out of the tea trade and spent just over ten years establishing his lucrative fruit-importing business. He then retired early following Fyffes' merger with the Irish firm Elder Dempster and Company.[6] It is perhaps because Edward retired at such a young age that historical literature appears to have largely omitted him from the archives.

Local man David East worked for Fyffes in Gloucester during the 1960s and recalls the old warehouse down by Gloucester train station. The bananas arrived green on stalks by train. Prior to leaving the firm, Edward Fyffe contributed to the revolutionary refrigeration process that inhibited the ripening process during transportation. Warehouse staff would cut the bananas from the stalks, weigh them and then pack them into wooden boxes. The Gloucester warehouse distributed bananas to all the major retailers like Tesco and Sainsbury's, alongside smaller independent local grocers right up until the 1970s, when it closed.

One of county's most acclaimed greengrocers must be L. E. Riddiford established in 1928 and still going strong today. Located in the market town of Thornbury, it

Woody's Fruit & Veg, Gloucester, 2018. (© Nick Kay)

was allegedly the original inspiration for the popular television series *Open All Hours*. However, the writer, Roy Clarke, denied this some years ago in Graham McCann's biographical account of the show, *Still Open All Hours: The Story of a Classic Comedy*, despite referencing it in the series several times and visiting the store itself as a young boy. Historically, Silk and Son were the toast of Cheltenham, grocers patronised by Edward VII and selling, among other goods, 'York and Canadian hams and cheeses of all varieties from the best dairies in the world abound in large quantities ... every kind of fruit, tinned, bottled and dried.'[7] The last record I can find for the store is in the 1950s. Arnold's Fruit and Veg is also fondly remembered, with its humble beginnings as a barrow on the corner of School Road in Bishops Cleeve, as early as the 1950s, and now still trading in the same village as a greengrocer's shop called 'Joyce Arnold'.

Several residents recall a grocer in Northgate Street, Gloucester, although the name appears to have been lost over time. It sold loose biscuits from wooden boxes with a bag of broken ones costing one old pence in the 1950s. Savoury biscuits and crackers were also displayed in big square tins with glass lids. One grocer's shop that is very much remembered by Jean Young (née Bircher) is Bircher's of Barton Street, Gloucester. The family lived behind the shop and Jean recalls one heart-stopping moment when her mother casually commented on all the birds in the sky hovering around an aeroplane. Her father replied 'that's not birds – it's bombs!' and they all swiftly ran into the house and their shelter under the stairs in the pantry. She remembers hearing all the saucepans falling off the shelves. Sadly, during that particular raid, a bomb was dropped on Barton Street and Jean's little neighbourhood friend, her mother and gran were all killed.

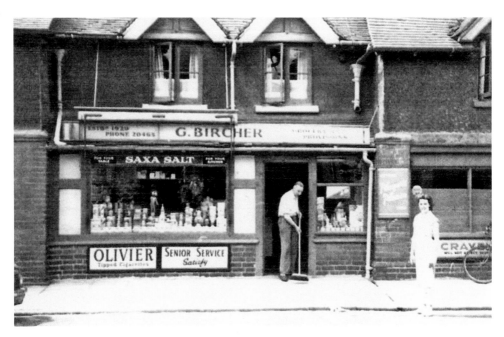

Bircher's of Barton Street, family grocer's, Gloucester. This image shows Jean and her father. (© Jean Young)

Despite the dominance of the big-name chain grocers, the county's growing diversity is reflected in many of its independent shops in the larger towns and cities today, like Yip Shing, run by Gloucester brothers Bee, Dan and Chi Yip, which has evolved into the biggest oriental supermarket of its kind in the county. Gloucester also has its own distinguished Indian food emporium, Motola and Sons, who have been trading in the city since 1970. Then there are the myriad of stylish farm shops and food emporiums

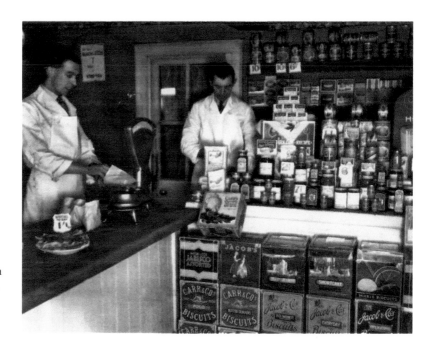

Bircher's of Barton Street, Gloucester, family grocer's, *c.* 1920s. (© Jean Young)

Gloucestershire seasonal veg. (© Nick Kay)

Local veg. (© Nick Kay)

selling everything from deli meats to seasonal local vegetables. There are too many to mention here, one of the best being Fillet & Bone, which occupies a centuries-old butcher's shop in the historic market town of Chipping Campden.

BREWING AND BEVERAGES

Exploring the architecture of some of the bigger urbanised towns in Gloucestershire, today you would never know the wonders of what existed there in a former lifetime. So many once thriving industrious streets have been demolished, grand buildings degraded to office blocks and farming land converted into housing and industrial sites. Perhaps some of the most visual reminders of Gloucestershire's heritage remain with the pubs and inns, many of which have been standing for centuries.

The Bath Tavern, Bath Road, Cheltenham, was once the favoured drinking spot for local performers and artistes appearing at the former Opera House (now the Everyman Theatre). Paul Bloxsome's collection of autographs and journals accrued by his great-grandmother, Blanche Cheshire, and supported by stories from his grandmother, Dorothy Bloxsome (née Cheshire), both of whom worked in the pub during its heyday, reveal a wealth of talented patrons who frequented the bar after going on stage during the late nineteenth and early twentieth centuries: Including, J. E. Teague, who was a professional violin and cornet player; composer Leonard Gautier; Harry Bartlett of J. W. Turner's renowned English Opera Company; the actor and stage-manager

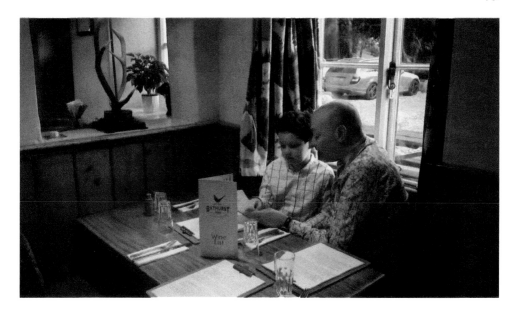

Above: Bathurst Arms, North
Cerney. (© Emma Kay)

Right: Royal Hop Pole,
Tewkesbury. (© Nick Kay)

Above: Bath Tavern, Cheltenham, favoured refreshment spot for Cheltenham performers of old. (© Nick Kay)

Left: Autograph taken at the Bath Tavern of famous violinist Henry Caville. (© Paul Bloxsome)

Edward Broadley; violinist Henry Caville; the actor Reginald Davis; and many others. Paul discloses that 'they used to go to the smoke room (the front right area of the bar) and smoke and drink after shows. My great-grandma had two autograph books which the actors and actresses signed, drew and wrote music in whilst enjoying a drink or two ... until it was sold in 1999.'

Apparently, the intimate panelled bar room was originally one of the smallest public bars in England, measuring just 6 by 10 feet. To the right of this was a larger room where drinks could be procured from a hatch service.

> *Oh! that we two were Maying in the leafy month of June, neath a summer sky in mid July, on an August afternoon.*
>
> *A few lines, but not from a poet.*
>
> *Harry Bartlett.*
> *J.W. Turner's English Opera Co.*
> *Apl. 3/09.*

Above left: Autograph taken at the Bath Tavern of operatic actor Harry Bartlett. (© Paul Bloxsome)

Above right: Picture of the famous violinist Henry Caville. (© Paul Bloxsome)

Below: Charabanc staff outing, Bath Tavern, Cheltenham, *c.* 1920s/30s. (© Paul Bloxsome)

Left: Fred Cheshire, third from left, outside the Bath Tavern, Cheltenham. (© Paul Bloxsome)

Below: Blanche Cheshire retiring as landlady of the Bath Tavern, with daughter Dorothy in the background. (© Paul Bloxsome)

Paul Bloxsome never met his grandfather Fred, who died in 1969, three years before he was born. His grandmother, Dorothy Bloxsome, died aged 101 having lived in Cheltenham virtually all of her life. She was actually born in the Bath Tavern and worked for some years behind the bar, before motherhood took over. The pub remained in the family until the 1980s. The Cheshire family ran the Bath Tavern for 133 years.

Cirencester Brewery, based in Cricklade Street and operated by the local bankers Cripps & Co., until the latter part of the nineteenth century had a complex history of takeovers and mergers. Stroud Brewery once contributed hugely to the area's beer manufacturing from the very early 1800s, until it amalgamated with Cheltenham and Hereford Breweries Ltd during the 1960s. Today a new Stroud Brewery exists, producing a broad range of organic craft beers including Budding, Tom Long, Big Cat, Hop Drop and many other thirst-quenching varieties. MerryDown is another fairly historic business, manufacturing popular ciders, started by three friends in 1946. Based in Gloucester, it is now one of the county's most successful businesses. Other Gloucestershire breweries of note include Cirencester's Corinium Ales Ltd, Hillside Brewery in Longhope and Donnington Brewery based in Stow-on-the-Wold, which continues to use the thirteenth-century mill wheel purchased by Richard Arkell in 1827 to drive the pumps that brew their unique beer. As Geoff Sandles notes in his 2016 book *Brewing in Gloucestershire*, 'Any attempt

Former site of Cirencester Brewery, Cricklade Street, Cirencester. (© Nick Kay)

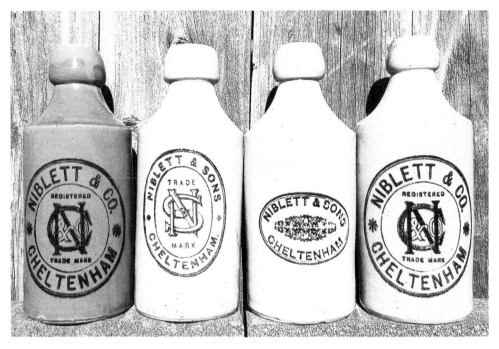

Niblett & Sons ginger beer bottles from the collection of Steve Lawrey. (© Steve Lawrey)

to accurately document the existence of every brewery, large and small, that has ever existed in the county of Gloucestershire would be an ambitious project...' So, if you are looking for more information about brewing in particular in the county, please do refer to his comprehensive book for a more detailed, but not definitive, guide.

Niblett and Sons of Cheltenham were one of the county's oldest suppliers of ginger beer. Charles Niblett, originally from Bristol, moved to Cheltenham in 1851 and began the trade of supplying ginger beer locally. By the 1870s the company had run into financial difficulties and was rescued by a family branch of the company: Niblett of Stroud. The merged company continued to provide award-winning ginger beer, alongside other soft drinks across Gloucestershire, right up until the 1940s. The Cotswold Mineral Water Co. Ltd, was also located in Cirencester in 1907, but folded just ten years later, acquired by Niblett and Co., based in Stroud and Cheltenham, which continued to thrive at least into the 1950s.

Established just five years ago, the Cotswold Hills Spring Water continues to reap the rewards of some of the Cotswolds finest springs.

A group of students at the Royal Agricultural University in Cirencester created a groundbreaking social enterprise in 2007 when looking to generate funds to support business start-up ideas. Muddy Wellies has grown in strength over the years and works collaboratively with Weston's Cider and Bath Ales. And let's not forget some of the much smaller independent companies like Spinner's Tale Cider, whose traditional farmhouse cider, made from apples collected from Ebrington Manor Farm, yield a perfectly balanced medium-sweet brew along with James McCrindle's Blakeney-based Perry.

Above: Royal Agricultural
University, Cirencester.
(© Nick Kay)

Right: Wine from Strawberry
Hill Vineyard. (Courtesy of
Shakespearesmonkey under
Creative Commons 2.0)

In the nineteenth century the Cotswold Hills were said to still be visually terraced with
the remains of vineyards, many of which continued to thrive in the 1700s. The Romans
first introduced grape growing into Britain and some of the reasons why the county
failed to sustain its once fruitful yields has been attributed to the climate and weather
conditions, along with the popularity for early French imports. Apparently, there was
once a very successful vineyard at Cromhall, a village in South Gloucestershire, from
which some ten hogsheads of wine were produced annually.[8] (One hogshead is equal
to around 300 litres of wine.) Today there are a few vineyards in Gloucestershire
including Woodchester Valley, Three Choirs, Strawberry Hill Vineyard and Poulton
Hill estate, along with a variety of specialist distilleries that create novelty liqueurs,
spirits and organic delights.

EVERYBODY ELSE

A pottery has existed since 1800 on the site of Winchcombe Pottery, located in the village of the same name, around 10 miles outside of Cheltenham. Traditional stoneware for the house and kitchen is still produced today. The former Greet or Beckett's Pottery once produced a wealth of farmhouse wares for the wider surrounding area. An old reference to Greet potteries and Mr Beckett reveals that bricks and tiles were also manufactured there.[9] The pottery used clay dug from a pit around half a mile away. It was then washed in a wash mill, strained and then left to form the right consistency for moulding. The business survived a great fire in 1866, the unfortunate situation of employing a local burglar and the death outside the property of a sixteen-month-old girl run over by a passing cart.

Following the deaths of various family members, the potteries, along with its six-bedroomed house, warehouses and orchard were sold for just over £275 in 1923 to a local farmer.[10] Three years later the old pottery was leased out by Michael Cardew, an ambitious protegee of the famous Bernard Leach and ever since has maintained its position in the county as one of the oldest surviving potteries, making everything from 8-pint casseroles, to salad bowls, jam pots, butter dishes and salt pigs. Creed Foodservice is a local food wholesale and distribution company that was originally a cash and carry (known as Linbar), established in 1972 by Terry Creed. Now run by his sons, the business is ranked one of the most successful in the country with a

Winchcombe Pottery, external view. (© Nick Kay)

Winchcombe Pottery wares. (© Nick Kay)

turnover of some sixty-three million pounds. One very long-standing local producer in Gloucestershire was Cole and Lewis bacon curers, the earliest record for which I can find being 1877, the latest around the 1950s. The premises, located in Cirencester, were extended during the 1930s and locals recall a number of their many products, such as the Bath chap – a pig's cheek cooked and coated with breadcrumbs. The company used sawdust from the local Ryeford Saw Mills to smoke the meat. Similarly, Hillier's of Nailsworth, established by Issac Hillier, was a popular local bacon factory with its beginnings in 1819. Their pork pies were apparently notorious in the area and they originally made all their deliveries via horse and cart. I managed to acquire a price list of Hillier's products from 1898. Cuts of bacon were sold in middles, sides, gammons and fore-ends from 42 to 90 shillings. This would have been equivalent to around £153–£350 in today's money. Smoked bacon rashers cost sixty-five shillings per cwt. This was an old form of weighing, equivalent to around 55 kilograms. So, although this amount of bacon would have cost around £250, you would be getting an enormous

quantity of meat for your money. Sausages were even better value, at a cost of seven and a half old pence for one pound. That's around £2.50, with black puddings at half this price. Hillier's had a long and distinguished career, in which the firm went through mergers, expansions and an eventual takeover, leading to its demolition in the 1990s.[11] The Cotswold Curer based in Cirencester continue to carry the baton for cured meat production today, while businesses like the Real Boar Company are reinventing this ancient art, with farmer Simon Gaskell making salamis and chorizos from his own free-range wild boar.

Similarly, Severn and Wye Smokery contribute to the county's abundance of specialist skilled manufacturers, with a particular passion for the old local fishing ways and supporting a range of some of the best of Gloucestershire's producers. Possibly the biggest company of this kind in Gloucestershire, based in Westbury-on-Severn, the Severn and Wye Smokery is situated between two great salmon rivers. Inspired by a childhood spent fishing and a desire to grow and expand over many years, the business now includes a fish market, chef's larder, shop and café.

The Artisan Kitchen is an award-winning small company who make and sell a range of preserves from their Gloucester kitchen and among other wonderful products, claim to 'make Blaisdon red plum jam from rare Gloucester plums ... the only commercial producer of this glorious jam, unique to our county'.

On the spicier end of the spectrum, established some fifteen years ago, Hot Headz, based in Stroud, boasts stocking the widest range of hot sauces in the UK, while The Yubberton Chutney Company sources virtually all of their ingredients from the village of Ebrington (or Yubberton, as its residents call it), using age-old recipes adapted for the modern market.

Daylesford Farm products, based near Kingham, have become well known nationally for their award-winning organic products, combining a cookery school, shops, accommodation, practical workshops with a range of other locations across the country. At the forefront for over forty-five years has been Lady Bamford, who has pioneered organic farming, recognising the pitfalls of plastic way before it became fashionable to discuss. On her farm in the Cotswolds she has bred various rare breeds of sheep and cattle, grown great orchards and reared colonies of bees.

Gloucestershire is also responding to the more contemporary food trends with traders like Maz Barchus, a small independent baker who has been making and selling her 'Free From' products for a number of years across the county. Her biggest claim to fame is selling baked goods from her stall in Stroud to television personality Keith Allen. Gloucester Brewery assert that all their bottle beer is vegan friendly, while Asparagasm, based in Nailsworth, run a variety of vegan and gluten-free workshops and events. Poco Culina run an innovative plant-based delivery and catering service in Cheltenham. While more recently, cousins from Gloucester, Sebastian Rey and Reuben Lawrence, are successfully running the unique 'Sowl Fuud' vegan takeaway service in Eastgate Street – the first of its kind in the city.

As a county steeped in folklore, which precedes much of what is covered in this book, Gloucestershire's relationship with food can be traced back as far as pagan ceremonies, such as the more contemporary labelled 'Puppy Dog Pie Feast'. Yes, originally young

Gluten-free
products made by
Maz Barchus.
(© Maz Barchus)

dogs and goats were indeed sacrificed to ensure the fertility of local flocks. As a Christian county, Gloucestershire continued to mark this ceremony, particularly in the town of Painswick, where the church and local children of the parish held an annual festival and many households kept an effigy of a china dog, representative of the original contents of the feast day celebrations.[12] Incidentally, this isn't the only ancient festival related to food that this town commemorated. 'Nutcrack Sunday' was a custom followed in Gloucestershire on the Sunday before Michaelmas, when nuts had to be cracked and eaten in church. It was also known as 'Clipping Sunday' from an older custom involving children holding hands and walking round the church singing or clipping the yew trees. The custom of cracking the nuts was apparently still being honoured in Painswick during the 1950s.[13] Customs like this abound throughout the county. At St Briavel's in the Royal Forest of Dean, bread and cheese cut into small squares were brought to the church on Whitsun Day and thrown from the gallery down to the congregation to catch.[14] And older still are the ceremonies of The Bull Club in Cirencester, who used to commemorate a ritual Jacobite supper club where

Left: Gloucester Farmers' Market. (© Nick Kay)

Below: The Jolly Nice, Frampton Mansell. (© Nick Kay)

Above left: Vibrant food and drink quarter, Gloucester Quays. (© Nick Kay)

Above right Hobbs House Bakery market stall. (© Nick Kay)

oysters were served up (when in season), along with tripe and onions, or calf's head and toasted cheese, all washed down with jugs of ale and stout.[15]

There is something esoteric about Gloucestershire and I am fascinated by the way in which its ancient marketplaces continue to endure, how its venerable pubs and inns continue to generate excellent food, and how its farm shops and rural cafés continue to evolve, such as the family-run Jolly Nice, who five years ago converted an old petrol station into a unique 'foodie destination'. Gloucestershire continues to reinvent itself, but always while keeping one foot in the past.

Notes

INTRODUCTION

1. British Newspaper Library, Stroud News and Gloucestershire Advertiser (Saturday 20 June 1868).
2. Bell Gray, J., A Glossary of Provincial Words Used in Gloucestershire (London: John Gray Bell, 1851).

REGIONAL FARE AND LOCAL DISHES

1. British Newspaper Library, *Gloucestershire Echo* (Wednesday 25 March 1908).
2. Marshall, W., *The Rural Economy of Gloucestershire* (London, 1796).
3. British Newspaper Library, *Cheltenham Chronicle* (Thursday 13 May 1830).
4. British Newspaper Library, *Gloucester Journal* (Saturday 28 Jan 1928).
5. British Newspaper Library, *Birmingham Daily Gazette* (Thursday 30 March 1950).
6. British Newspaper Library, *Wiltshire and Gloucestershire Standard* (Saturday 17 February 1900).
7. Vorwald Dohner, J., *The Encyclopaedia of Historic and Endangered Livestock and Poultry Breeds* (Yale University Press, New Haven and London 2001), p.185.
8. British Newspaper Library, *Birmingham Dily Post* (Tuesday 14 October 1975).
9. British Newspaper Library, *The Tewkesbury Register and Agricultural Gazette* (Friday 20 Nov 1959).
10. British Newspaper Library, *Morning Post* (Tuesday 09 April 1833).
11. British Newspaper Library, *Stroud News and Gloucestershire Advertiser* (Friday 10 April 1874).
12. Baggs, A. P., Jurica, A. R. J., Sheils, W. J., 'Bisley: Introduction', *A History of the County of Gloucester: Volume 11*, Herbert, N. M., Pugh, R. B. (ed) (Bisley and Longtree Hundreds, London, 1976), pp. 4-11.
13. The Three Ways Hotel, The Pudding Club [Online] (cited 10 September, 2018) Available from http://www.threewayshousehotel.com/pudding_club).
14. Shakespeare, W., *The Complete Works of William Shakespeare* (Wordsworth Editions, Hertfordshire, 1996), p. 463.

15. *The Magazine of Domestic Economy*, Volume 4. (W. S. Orr and Company, London, 1839), p. 238.
16. British Newspaper Library, *Chelmsford Chronicle* (Friday 08 October 1784), p.4.
17. Plenderleath, W. C., *The White Horses of the West of England: with notices of some other ancient turf-monuments* (Allen and Storr: London, 1892), p.18.
18. British Newspaper Library, *The Examiner* (Sunday 03 January 1841).

FOOD AND DRINK ON THE STREETS: THEN AND NOW

1. Thirsk, J. (ed), *The Agrarian History of England and Wales: 1500-1640* (Cambridge University Press, 1967), p.467.
2. Hawkins Fisher, P., *Notes and Recollections of Stroud, Gloucestershire* (John Trubner and Co., London and J. Eliot, Stroud, 1871), p.271-272.
3. *Kelly's Directory of Gloucestershire* (1914), p.122.
4. British Newspaper Library, *Cheltenham Chronicle* (Thursday 19 May 1814).
5. Bennet, J., *A Tewkesbury Guide* (James Bennett, Tewkesbury, 1830), p.86.
6. British Newspaper Library, *Gloucestershire Echo* (Tuesday 15 Feb 1944).
7. Shaaber, M. M. (ed), *Henry V* (J. B. Lippincott Company, Philadelphia and London, 1940), p.600-602.
8. British Newspaper Library, *Cheltenham Chronicle* (Saturday 27 July 1895).
9. Hawkins Fisher, P., Notes and Recollections of Stroud, Gloucestershire (John Trubner and Co., London and J. Eliot, Stroud, 1871), p.23.
10. British Newspaper Library, *Gloucester Journal* (Saturday 17 Nov 1917).
11. British Newspaper Library, *Gloucestershire Echo* (Wednesday 03 Dec 1919).
12. British Newspaper Library, *Gloucester Journal* (Saturday 17 January 1920).
13. British Newspaper Library, *Gloucester Citizen* (Friday 03 April, 1925).
14. British Newspaper Library, *Cheltenham Mercury* (Saturday 17 Jan 1874).
15. British Newspaper Library, *Gloucester Journal* (Monday 01 October 1798).
16. British Newspaper Library, *Gloucester Journal* (Saturday 10 June, 1939).
17. British Newspaper Library, *Gloucestershire Chronicle* (Saturday 23 September, 1916), p.3.

PRODUCERS AND COOKS

1. Gell, R., Bradshaw, T., *The Gloucestershire Directory*, (J. Roberts, Gloucester, 1820).
2. British Newspaper Library, *Wiltshire and Gloucestershire Standard* (Monday 31 October, 1842).
3. British Newspaper Library, *Gloucestershire Echo* (Thursday 17 Jan 1946).
4. British Newspaper Library, *Birmingham Daily Post* (Friday 01 July, 1977).
5. British Newspaper Library, *Stroud News and Gloucestershire Advertiser* (Friday 09 Oct, 1891).

6. Myers, G., *Banana Wars – The Price of Free Trade: A Caribbean Perspective* (Zed Books, London and New York, 2004), p.5.
7. British Newspaper Library, *Gloucestershire Echo* (Wednesday 12 March, 1902).
8. Ellacombe, H.N., *The Plant-Lore and Garden-Craft of Shakespeare* (Courier Dover Publications, New York, 2017), p.324.
9. British Newspaper Library, *Cheltenham Chronicle* (Saturday 11 January, 1908).
10. British Newspaper Library *Gloucestershire Echo* (Tuesday 07 August, 1923).
11. Makemson, A., 'Hillier's Bacon Curing Factory, Newmarket, Nailsworth', in *Gloucestershire Society for Industrial Archaeology Journal* (2005), p.30-36.
12. British Newspaper Library, *Cheltenham Chronicle*, (21 September 1935).
13. British Newspaper Library *Gloucester Citizen* (Monday 25 September, 1950).
14. British Newspaper Library *Irish News and Belfast Morning News* (Saturday 12 May 1894).
15. Ainsworth-Davis, J.R., *Cooking Through the Centuries* (J. M. Dent, London, 1931), p.166.

Bibliography

Ainsworth-Davis, J. R., *Cooking Through the Centuries* (J. M. Dent, London, 1931).

Baggs, A. P., Jurica, A. R. J., Sheils, W. J., 'Bisley: Introduction', *A History of the County of Gloucester: Volume 11*, Herbert, N. M, Pugh, R. B., (ed) (Bisley and Longtree Hundreds: London, 1976).

Bell Gray, J., *A Glossary of Provincial Words Used in Gloucestershire* (John Gray Bell, London, 1851).

Bennet, J., *A Tewkesbury Guide* (James Bennett, Tewkesbury, 1830).

Ellacombe, H. N., *The Plant-Lore and Garden-Craft of Shakespeare* (Courier Dover Publications, New York, 2017).

Gell, R., Bradshaw, T., *The Gloucestershire Directory* (J. Roberts, Gloucester, 1820).

Gloucestershire Federation of Women's Institutes., *Gleanings from Gloucestershire Housewives* (Albert E. Smith, Gloucester, 1949).

Goding, J., *Norman's History of Cheltenham* (Longman Green, Cheltenham 1863).

Hadfield, A., M., *Williver's Luck* (Bobbs-Merrill, Indianapolis 1966).

Hawkins Fisher, P., *Notes and Recollections of Stroud, Gloucestershire* (John Trubner and Co., London and J. Eliot, Stroud, 1871).

Kelly's Directory of Gloucestershire, (1914).

Makemson, A., 'Hillier's Bacon Curing Factory, Newmarket, Nailsworth', in *Gloucestershire Society for Industrial Archaeology Journal* (2005).

Marshall, W., *The Rural Economy of Gloucestershire* (London,1796).

McCann, G., *Still Open All Hours: The Story of a Classic Comedy* (Random House, London, 2014).

Myers, G., *Banana Wars – The Price of Free Trade: A Caribbean Perspective* (Zed Books, London and New York, 2004).

Plenderleath, W. C., *The White Horses of the West of England: with notices of some other ancient turf-monuments* (Allen and Storr, London, 1892).

Shaaber, M. M. (ed), *Henry V* (J. B. Lippincott Company, Philadelphia and London, 1940).

Shakespeare, W., *The Complete Works of William Shakespeare* (Wordsworth Editions, Hertfordshire, 1996).

The Magazine of Domestic Economy, Volume 4. (W. S. Orr and Company, London, 1839).

Thirsk, J. (ed)., *The Agrarian History of England and Wales: 1500-1640* (Cambridge University Press, 1967).

Vorwald Dohner, J., *The Encyclopaedia of Historic and Endangered Livestock and Poultry Breeds* (Yale University Press, New Haven and London 2001).

ONLINE RESOURCES

British Newspaper Library https://www.britishnewspaperarchive.co.uk/

Charles Martell http://www.charlesmartell.com/

Three Ways Hotel http://www.threewayshousehotel.com/pudding_club